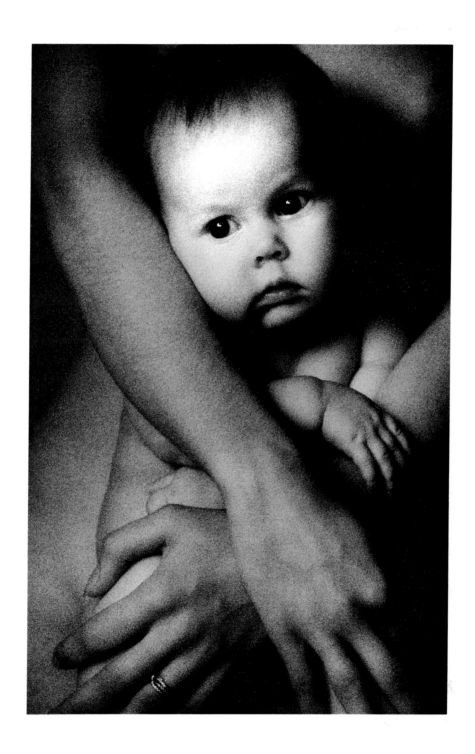

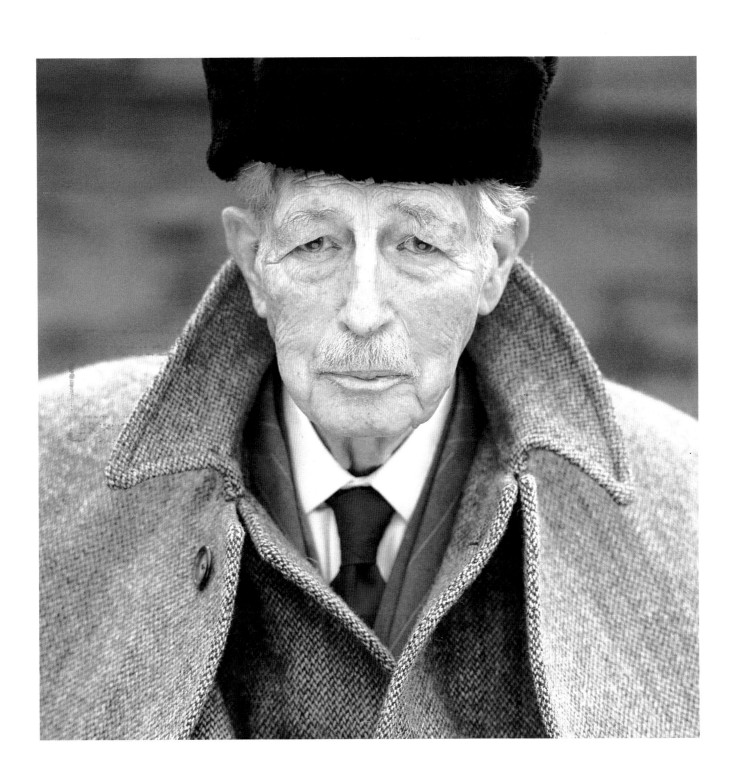

LICHFIELD
IN RETROSPECT

TEXT BY CHARLES MOSLEY

WEIDENFELD & NICOLSON · LONDON

First published in Great Britain in 1988 by
George Weidenfeld & Nicolson Ltd
91 Clapham High Street
London sw4 7TA

ISBN 0 297 79396 9

Designer: Harry Green
Editor: Joanna Edwards

Phototypeset by Keyspools Ltd, Golborne, Lancashire
Colour separations by Newsele Litho Ltd
Printed in Italy by Printers Srl, Trento
Bound by L.E.G.O., Vicenza

Half-title: Babe in arms, 1973

Frontispiece: Harold Macmillan,
Earl of Stockton, 1984

CONTENTS

Acknowledgements

I am enormously grateful to the following:

Peter Kain, photographer and my assistant since 1971, who makes
everything happen – for which my thanks are inexpressible

Chalky Whyte, the perfectionist who has worked with me since 1973 and
who printed up all the black and white photographs for this book

Terry Boxall, retoucher at *Vogue*

Diana Vreeland, ex-editor of American *Vogue*, who gave me my first *Vogue*
commission

Beatrix Miller, ex-editor of *Vogue* in London

Jocelyn Stevens, for giving me my first assignments on *Queen*, and for
many less salutary memories

Dmitri Kasterine and Michael Wallis, friends and mentors, in whose studio
I learnt the basics about photography

The late Tom Blau of Camera Press, whose advice and encouragement
were invaluable

Richard Dawkins, Johnnie Eldon, Billy Keating and Elizabeth Ramsay, for
assistance in the Sixties, and my secretaries in all three decades

Barry Taylor, managing director of Olympus cameras, whose equipment I
have used for the majority of the pictures

Burberrys and Unipart, whose commissions I have enjoyed for many years

Michael Dover at Weidenfeld & Nicolson and freelancers Joanna Edwards
and Harry Green who worked very hard on this book

Charles Mosley, who did meticulous research for the text

and many other friends whose support has been of inestimable value
through the years.

PATRICK LICHFIELD

Chronology

25 APRIL The Hon. Thomas Patrick John Anson, later to be known as Patrick Lichfield, was born in his grandmother's house in Embankment Gardens, London. He was the only male child and heir of Lt-Col. Lord Anson, a Grenadier Guards officer who himself was elder son and heir of the Fourth Earl of Lichfield. The Anson family seat is Shugborough in Staffordshire, and Lichfield spent a large part of his childhood there.

His mother was Anne, daughter of The Hon. John Bowes-Lyon, himself second son of the Fourteenth Earl of Strathmore and Kinghorne and brother of the then queen (now the Queen Mother), who stood godmother to Patrick Lichfield. The latter is therefore first cousin once removed to the present Queen.

3 SEPTEMBER The Second World War began. Lord Anson was to be away from home for almost six years of active service.

1941

7 JUNE Lady Elizabeth Anson, Patrick Lichfield's sister, was born. George VI became her godfather.

The Hon. Patrick Anson, 1942

1947
Patrick Lichfield was given his first camera. In the spring term he went to Wellesley House preparatory school in Broadstairs, Kent.

1952–57
He was educated from the age of thirteen at Harrow. By taking leaving pictures of fellow Harrovians at one shilling and sixpence (7½p) a time, he successfully undercut the town photographers Hill & Saunders. His equipment at first consisted of nothing more elaborate than a Kodak Retinette, but as his earnings grew he acquired his first exposure meter and flashgun. In addition to being instructed in the orthodox school curriculum he took steps to learn film processing at a laboratory in the town. (Harrow has turned out several noted photographers. William Henry Fox Talbot and Cecil Beaton went there, as

First camera, 1947

did Sir Geoffrey Shakerley, subsequently Lichfield's brother-in-law.)

1958
4 MARCH With the death of his father Patrick Lichfield became Lord Anson and immediate heir to the earldom.

1959
Lichfield joined the Grenadier Guards, following training as a cadet at Sandhurst.
 During his time in the Grenadiers, with whom he was serving as a volunteer rather than as a national service conscript, he spent some time abroad in the British-administered section of Cameroon, where the Grenadiers were sent to keep the peace pending a plebiscite to decide the future of that country. As part of his general training in Britain he went on a photographic interpretation course.
 This same year he took possession of a minute flat in Belgravia, one of London's most desirable residential areas, and set up a darkroom there.

Sgt. Bailey and Lt. Lord Lichfield, Cameroon, 1960

1960

6 MAY The photographer Antony Armstrong-Jones married Princess Margaret.

14 SEPTEMBER Lichfield's grandfather died. As the Fifth Earl of Lichfield the young Guards officer was faced with huge death duties, since his father had predeceased his grandfather. Shugborough – the house but not the estate – was made over to the nation in settlement.

Some idea of the extent to which the Ansons' property had been diminished by tax demands – particularly crippling when the inheritance misses a generation – can be grasped by the fact that whereas at one time they had owned 100,000 acres, and even when Lichfield was born retained 30,000, the total estate following his accession was reduced to 6,000 acres. Conscious of this overall decline, he once explained in a television interview, 'My family has often failed to take commercial opportunities.' However, his success as a professional photographer has gone some way towards restoring the family inheritance.

1961

26 JANUARY The press reported that Lichfield was part of an Army contingent billeted on the Shugborough estate, his own property.

1962

14 OCTOBER Lichfield left the Army with the rank of subaltern. The same day he started work as assistant to Dmitri Kasterine and Michael Wallis, partners in a photographic studio. He stayed with them for three years. There was some opposition in the family to this choice of profession, thought by many people at the time to be unsuitable. Since his father was dead and his mother now lived in Paris, where she had married as her second husband Prince Georg of Denmark, there was no immediate family to struggle against. Nevertheless, his allowance was curtailed.

The prejudice flourished in British society despite the fact that Antony Armstrong-Jones, now the Earl of Snowdon, continued to take photographs professionally after his marriage to the Queen's sister, and despite the complete acceptance of the photographer Cecil Beaton as a social figure in his own right.

Ironically, there was perhaps no other modern technological development which right from the start had had such a wealth of participants with broadly upper-class connections. Julia Margaret Cameron, who had taken a portrait study of Patrick Lichfield's great-great-grandfather the Second Earl, was sister-in-law of the Third Earl Somers. William Henry Fox Talbot descended from the Talbot Earls of Shrewsbury and the Fox Strangways Earls of Ilchester and lived as a prosperous country gentleman in the splendid mansion of Lacock Abbey. Prince Albert expressed interest in Fox Talbot's activities, and in 1853 the French photographer Antoine-François-Jean Claudet was asked officially by Queen Victoria to undertake work at court. The Queen later appointed the photographer Francis Bedford (1816–94) a member of the Prince of Wales's suite during the latter's tour of the Middle East from 1862 to 1863. Nevertheless until well into the Sixties conventional British people considered that to practise photography professionally was socially demeaning.

1963

Although still employed as assistant to Kasterine and Wallis, Lichfield had begun to take photographs professionally himself. (A paragraph appeared in the *Daily Express* announcing that he had recently resigned his commission in the Grenadiers to practise photography.) He began with family shots. Connections from schooldays proved useful here, providing a steady trickle of weddings and christenings. Quite early on Lichfield showed an

ability to take good pictures of children, and it was the sight of a number of his portraits of children in various parents' houses that first attracted the attention of the influential 'Jennifer' (Betty Kenward), of 'Jennifer's Diary' in *Queen* magazine (now *Harpers and Queen*). She was to prove a useful recommendation and the source of a number of commissions.

1964

This was the year Lichfield was given his first royal assignment: a photograph of Princess Anne-Marie of Denmark (later Queen of Greece until the monarchy was abolished). The newspaper commissioning the work is thought not to have realized that she was connected by marriage with its photographer.

Fashion shot, 1964

A session with the Grand Duke Jean of Luxembourg and his family followed.

Woman's Realm, a popular weekly magazine, carried a feature on Lichfield that reflected the growing recognition of his name.

1965

29 APRIL Photographs by Lichfield of Princess Margaretha of Sweden, her husband John Ambler and their daughter Sybilla appeared in the *Sun* and *Daily Express*.

5 MAY A reference to Lichfield's having 'taken up' photography appeared in the press. (This report was not only two and a half years late but misleading in implying dilettantism.) The same month he took photographs of his first famous American sitter, Zsa Zsa Gabor, in Mayfair, London.

13 JULY Lichfield was commissioned by the New York magazine *Status* to photograph several of the young Britons who were transforming national life. The first session was with Michael Caine. Soon after, Rita Tushingham, an actress then celebrated for her part in *Girl with Green Eyes* (1964), sat for him.

The byline 'Patrick Lichfield' appeared for the first time; it was in the William Hickey column of the *Daily Express* and was printed under a photo of Madeleine Rampling (cousin of the actress Charlotte Rampling). This led to a contract with the *Express* for twelve shots a year, comprising news, features and social items. Lichfield had by now taken regularly to photographing debs at deb dances. His ability to put names to faces made him an asset to Derek Jameson, at that time picture editor of the *Sunday Mirror*.

1966

31 MARCH The prime minister, Harold Wilson, called the second general election in eighteen months. Photographs by Lichfield of a former brother Guards officer, J.G. ('Algy') Cluff, were used by the latter in his campaign literature when he stood as Conservative candidate for a Manchester constituency.

16 APRIL *Time* published its cover story entitled 'London – The Swinging City'. It is usually said that this launched the notion of 'Swinging London'.

13 MAY The weekend supplement of the *Daily Telegraph* contained a feature article on Lichfield.

This year saw his first professional visit to Buckingham Palace – to photograph the Queen in connection with the state opening of Parliament on 21 April. Earlier in the year he had photographed the Duke and Duchess of Kent and their children – his first British royal commission.

He now had a regular job providing photographs for *Queen*, the magazine Jocelyn Stevens had bought in the late Fifties and transformed into one of the most influential arbiters in the Sixties of what to think and wear, whom to be seen with and know, and where to eat and drink. *Queen* had made a habit of commissioning work from photographers of distinction and had published the work of Cartier-Bresson and Norman Parkinson.

A further boost to Lichfield's career came with a summons by Diana Vreeland, queen of New York fashion and presiding deity at American *Vogue*, to meet her in Paris. There she commanded him to bring her photographs of the world's best dressed man. Correctly guessing this to be the Duke of Windsor, Lichfield hastened to the duke's château outside Paris. He managed to take highly original pictures of the duke and duchess laughing, of the duke tying his tie and of the duke sitting wearing his kilt.

The same year Lichfield moved into a small studio-cum-flat in Aubrey Walk, Kensington, London.

1968

Lichfield took his first formal portrait photograph of Princess Margaret. In May, his first fashion photograph appeared in the *Sunday Times*.

This was the year he woke up one morning to discover that dinner and a photographic session 'with Patrick Lichfield' had been offered by *Queen* as the prize in a 'Win a Millionaire' competition. Entrants had to list in order of precedence eight features supposedly common to millionaires.

He now began to spend more time in New York. Indeed from now until 1973 he practically lived there, at first under contract to Diana Vreeland and American *Vogue*, later freelance. (Only four other English photographers have been contracted by American *Vogue*: Beaton, Parkinson, Snowdon and Bailey.) In those years he made a multitude of appearances on American television, becoming better known to the masses in the United States than in Britain.

While in New York he saw the controversial rock musical *Hair* (in which a then unknown actress, Diane Keaton, was appearing). On hearing that it was to transfer to London, and thinking it showed promise, he invested in it.

27 SEPTEMBER *Hair* opened in London at the Shaftesbury Theatre. It ran for 1,998 performances until the theatre roof collapsed. In June 1974 it opened again, running for another 111 performances.

Hair's London success gave Lichfield the wherewithal to buy a plot of land on Mustique, the Caribbean island belonging to the Hon. Colin Tennant (later Lord Glenconner). Princess Margaret had been

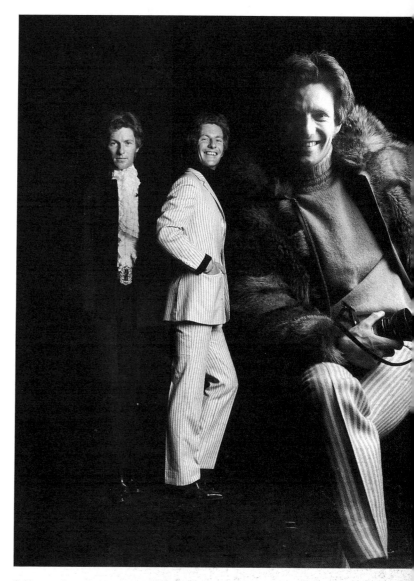

Self-portrait, 1967

given a plot of land on Mustique by Tennant as a wedding present, and the preceding year had started building.

Late that year the newly appointed director of the National Portrait Gallery, Roy Strong, mounted the first exhibition of photograph portraits ever held in Britain. The photographer thus honoured was Cecil Beaton, but all photographers benefited from the prestige the exhibition brought their art.

1969

13 JANUARY The American fashion pundit Eleanor Lambert's list of best dressed men for 1968 was published, with Lichfield in fourth place. The only other Englishman who appeared on the list was Cecil Beaton. Lichfield was to feature in the list for three years running.

25 APRIL Lichfield's thirtieth birthday also saw the last performance of the BBC radio serial *The Dales*, as *Mrs Dale's*

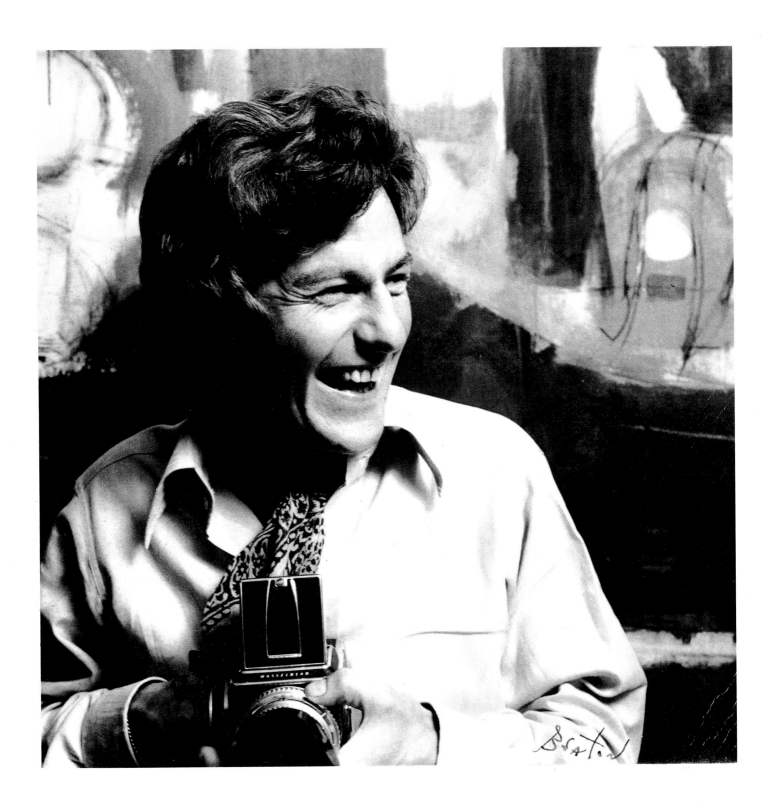

At Pelham Place, London, taken by Cecil Beaton, 1969

Diary had been renamed a few years earlier. For many people this marked the end of Old England.

25 MAY Lichfield was caricatured in the *Sunday Times* by the cartoonist Gerald Scarfe. The others featured in the collective lampoon of contemporary personalities were Vanessa Redgrave, David Frost, Kenneth Tynan, the disc jockey Simon Dee, Lady Antonia Fraser, Sir Gerald Nabarro MP and Mrs Mary Whitehouse.

26 DECEMBER Burke's club opened in Mayfair, with Lichfield, Michael Caine, Omar Sharif, Tom Courtenay and David Hemmings as investors. Burke's later ceased to be exclusively a club and became a restaurant open to all, specializing in traditional English food, such as roast beef with Yorkshire pudding, and fine wine.

During this year, Lichfield started working for British *Vogue*, with which he was associated regularly until 1972.

1970

The television documentary *Peer in Focus*, an examination of Lichfield's life, was broadcast by the BBC.

27 JULY *Oh! Calcutta*, an entertainment on various sexual themes devised by Kenneth Tynan, opened at the Roundhouse, in London's Chalk Farm. Like *Hair* it had appeared in New York before coming to England and Lichfield had invested in it. In the end, it easily outstripped *Hair*, with 3,900 performances in London alone.

1971

12 MAY Lichfield gave away Bianca Pérez Morena de Márcias at her wedding to Mick Jagger.

During the postal strike of that year he set up a private

Lichfield Studios, Aubrey Walk, Kensington, London, 1970

postal service called Rickshaw, and delivered 250,000 letters in six weeks. (Another celebrated photographer, the Frenchman Nadar, had done something along the same lines at the time of the Franco-Prussian war a century before.)

1972

The Queen's and the Duke of Edinburgh's twenty-fifth wedding anniversary was celebrated. To commemorate the event Buckingham Palace asked Lichfield to take a number of official photographs. Some he had shot at Balmoral already but others he took during a Far East tour aboard the royal yacht *Britannia*. The Australian Post Office used one of the Queen and the Duke of Edinburgh on postage stamps.

Lichfield now started doing commercial photography

on a wide scale. The work took on a different perspective when Burberrys asked him not just to photograph their raincoats but also to model them and allow his name to be used in the advertising.

During the American presidential election he covered the McGovern campaign as a photojournalist.

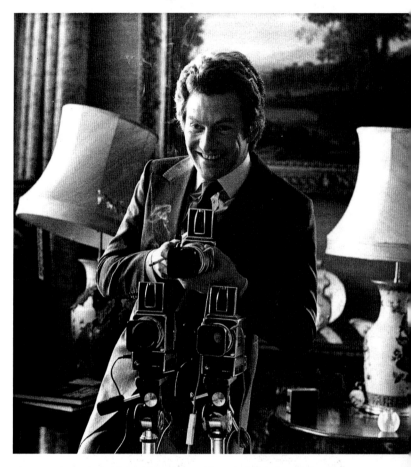

Photographing the bridesmaids on his wedding day, 1975

1973

Lichfield took photographs of Princess Anne and Captain Mark Phillips, who were married that year, for Post Office stamps.

1974

Lichfield was signed up by the *Radio Times*, one of Britain's largest circulation periodicals with some 12 million readers a week.

A one-man exhibition of his work was shown at the Royal Photographic Society and he became a Fellow of the British Institute of Professional Photographers.

1975

8 MARCH Patrick Lichfield married Lady Leonora Grosvenor, daughter of the Fifth Duke of Westminster.

He became a Fellow of the Royal Photographic Society. Normally a photographer becomes a fellow after being first a licentiate and then an associate, but Lichfield was invited to proceed direct to a fellowship, bypassing the intermediary stages. The RPS differs from the BIPP in being a body concerned with distinction in photography; it does not concern itself over occupational status and anyone may be a member, even if photography is just a hobby. The BIPP is the practitioners' association concerned with such matters as maintaining standards of professional conduct.

An exhibition of his photographs was held in Sydney.

1976
Early in the year, Lichfield had all his photographic equipment stolen. Olympus cameras approached him soon afterwards to ask if he would endorse their products in exchange for supplying him with equipment. He agreed and his name has been linked with Olympus ever since.

27 JULY Lady Rose Anson, Lichfield's elder daughter, was born.

In the studio at Aubrey Walk, 1981

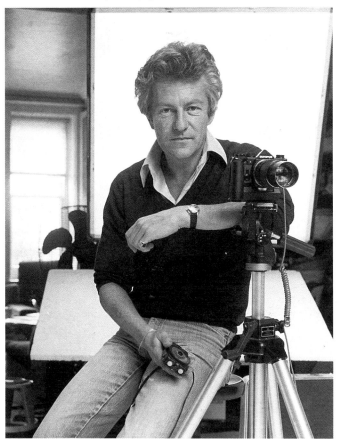

18 NOVEMBER Lichfield compered the Miss World contest with the French singer Sacha Distel at the Albert Hall in London.

1978
19 JULY Viscount (Thomas) Anson, Lichfield's son and heir, was born.

One-man exhibitions of Lichfield's photographs were held in San Francisco, Los Angeles, Chicago and New York.

1979
The first Unipart calendar, published late in 1978, continued to sell well. This had been shot by Lichfield in Provence the previous year and was the first of a succession of prestigious calendar commissions he was to execute for Unipart, a manufacturer of motor spare parts, each year except 1986.

Kodak asked Lichfield to shoot the pictures for their 1981 promotional calendar.

1980
8 AUGUST The Chinese restaurant Tai-Pan opened in Brompton, London; Lichfield was one of its directors.

1981
18 APRIL Lady Eloise Anson was born.

Lichfield was asked to take official photographs of the royal wedding between the Prince of Wales and Lady Diana Spencer in July.

His book *The Most Beautiful Women* was published, as was *Lichfield on Photography*. Exhibitions of his work were held at the Kodak and Olympus galleries in London.

1982
Madame Tussaud's installed a waxwork of Lichfield.

Exhibitions of his work were held in Tokyo, Hong Kong, London and Bristol, and his books *The Unipart Calendar Book* and *A Royal Album* were published.

1983
Lichfield was a guest on the radio programme *Desert Island Discs*.

Exhibitions of his photographs were held in Hawaii, Brighton and Wembley. His book *Creating the Unipart Calendar* was published. In addition to the annual commission to shoot the Unipart calendar, he was asked to shoot a calendar for the Far Eastern airline Cathay Pacific.

1984
Lichfield acquired a financial interest in the restaurant Pier 31 on the Thames in London.

Exhibitions of his photographs were held across the

United States. His 1985 Unipart calendar won a Kodak award for 'the best business calendar'.

1985

The satirical television programme *Spitting Image* featured a puppet of Lichfield.

Exhibitions of his work were shown in the United States, Bath and London, and *Hotfoot to Zabriskie Point*, an account by Jilly Cooper of shooting the Unipart calendar in Death Valley, California, was published.

Lichfield Studios moved to larger premises in north Kensington, London.

1986

Not the Whole Truth: an autobiography was published.

Two exhibitions of his work were held in London, one in the Science Museum and the other – a joint exhibition of photographs of Israel with Snowdon, Sir Geoffrey Shakerley and Eric Hosking – was opened by Prince Andrew in Selfridges, the Oxford Street department store.

White Horse whisky commissioned the first of two calendars shot exclusively by Patrick Lichfield.

1987

Andrew Lloyd Webber's musical *Cats* was produced in Hamburg; the photographs in the programme were taken by Lichfield.

The first edition of *Courvoisier's Book of the Best* was published. A guide to leading restaurants, hotels, shops and other consumer outlets around the world under Lichfield's editorship, the book traded on his considerable experience as a world-traveller.

Dunlop commissioned their 1988 centenary calendar.

1988

Deals, the new restaurant backed by Lichfield and his cousin Lord Linley, son of Princess Margaret and Lord Snowdon, opened in Chelsea Harbour, London, a development of luxury apartments and houses around a yacht marina on the Thames. Lichfield also became chairman of the Lachmead Group, which planned to build a chain of medium-price restaurants in Britain.

Unlike many figures who rose to prominence in the Sixties, Lichfield has remained steadily in the public eye. His enduring achievement has been to capture on film a unique series of pertinent images in each decade.

At Shugborough, 1986

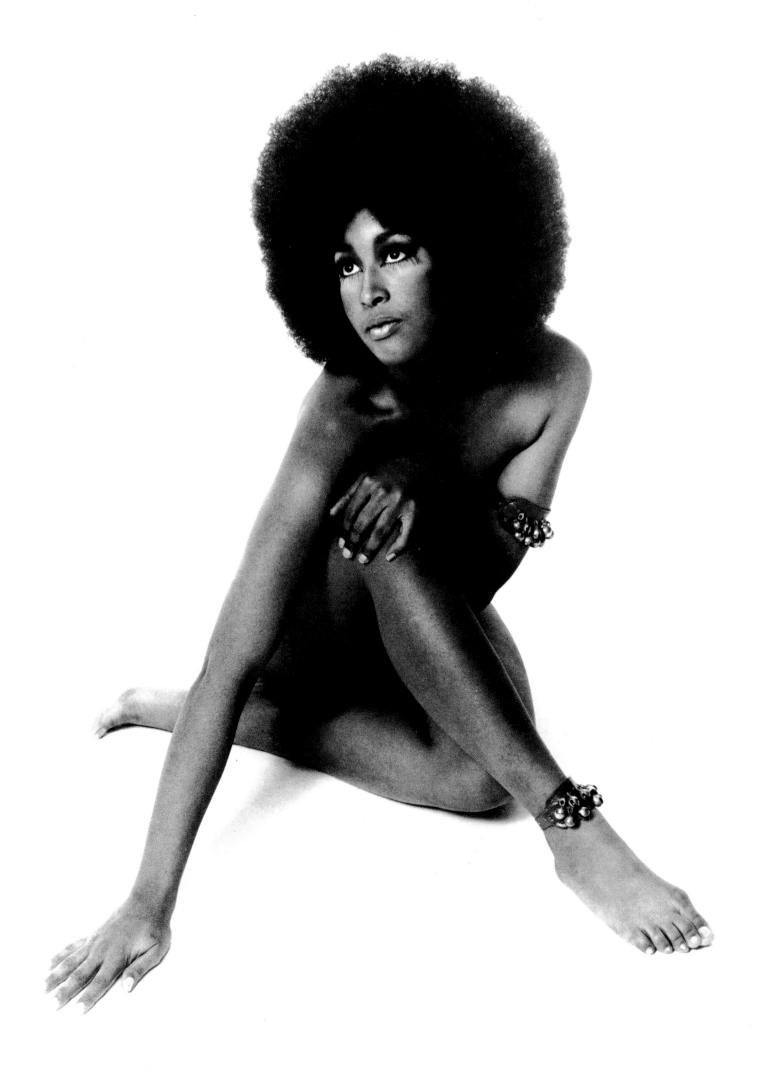

THE
1960s

Patrick Lichfield, 1969

Marsha Hunt, 1968

On this page and the one facing it appear two classic mementoes of the Sixties. Opposite: a naked, black, bushy-haired beauty – Marsha Hunt. She is Miss Hair in both senses of the word, for *Hair* (1968) the musical made her name as surely as she made fashionable the Afro style. As a substance hair, or rather the length of it, was in those days a major cause of battle between the young and the adults who still dictated standards of dress, deportment and coiffure.

Above: a lean, serious, clearly ambitious young man. There's a touch of Tom Courtenay about to play the Borstal boy hero in Tony Richardson's *The Loneliness of the Long Distance Runner* (1962). Actually it's an Old Harrovian earl temporarily short of funds because his trustees disapprove of the way he earns a living. In short, the photographer Patrick Lichfield.

Judging from the intensity of his expression, the earl in question is determined to succeed. He *did* succeed, but in his own way, a way that is typical of young men. The Sixties was like that, a time when young people's impatience with their elders proved to be much more than just another case of adolescent sulkiness. *Private Eye* destroyed statesmen who had seen off Hitler. Satire subverted the BBC. David Frost, aged only twenty-six, cowed several Very Important Persons, including the prime minister, the secretary of state for the colonies and leader in the Lords, the Wykeham Professor of Logic in the University of Oxford and a bishop of the established Church into breakfasting with him all at the same time. Such a coup is only slightly less impressive when one discovers that the celebrities in question were, respectively, those publicity-minded individuals Harold Wilson, Lord Longford, A. J. Ayer and John Robinson – suffragan of Woolwich and author of *Honest to God* (1963).

Versatility was another Sixties quality. Patrick Lichfield was successful not just as a photographer; he cannily invested in the very musical that made Marsha Hunt. *Hair* captured the spirit of the age so seductively that on the first night the Duke of Bedford climbed on stage at the end of the formal showing and proceeded to 'shake his bacon' along with those other members of the audience who had accepted the cast's invitation to come and dance. Six months later Princess Anne followed suit. *Hair* ran for over 2100 performances. Like the Sixties generally, it eventually played to, and to a certain extent won over, the very people it had started out to shock.

The diptych thus epitomizes the Sixties: a mixture of glamour – a little bizarre and more than a little fleeting – and youthful, wayward ambition, yet an ambition surprisingly often fulfilled.

The Sixties was the first decade in which it was widely possible to succeed in a way the older generation had traditionally viewed with disapproval, even contempt. Once parents would have dismissed photography as a mere hobby. Anyone enthusiastic about it would have been told to train for a proper career instead. The Sixties changed all that. Hairdressers may have failed subsequently to consolidate the forward positions they established in the Sixties, but at the time several became indubitably chic, the apotheosis of their recognition by the conventional world occurring with the admission of Mr 'Teasy-Weasy' Raymond to the Royal Enclosure at Ascot in 1969, although he had been excluded from it only the year before. The Sixties was very good to photographers too, with the difference that subsequent decades have continued beneficent. It became possible to earn not just a living through your lens, but status. Success got you into the gossip columns and onto television, not to mention the company of the world's most beautiful women.

Above all, women. Much of the horror conventional people had felt for professions such as photography, interior design and hairdressing arose not just from snobbishness but a suspicion that a chap who earned his living that way wasn't perhaps quite as keen on women as was usual. At best a photographer was envisaged as the kind of plausible gigolo who won over foolish dowagers, those trend-besotted old trouts every charlatan had been able to entrance since the world began.

The Sixties said to hell with all that. It became clear to even the starchiest of people that overt, sometimes blatant heterosexuals were at last

infiltrating those equivocal callings. They even came out in hairdressing. The best example is cinematic: Warren Beatty as a Lothario crimper in the film *Shampoo* (1975), evidently considered so much a Sixties phenomenon that it was set in 1968 to add verisimilitude. Yet oddly enough men dressed more flamboyantly, even effeminately, than at any time since the 1830s – a decade not unlike the Sixties in its zest for enjoyment.

A particularly interesting example of a profession the Sixties endowed with glamour was espionage. The James Bond books (the first of which were published in the Fifties), then films of the books like *Doctor No* (1962) and *From Russia With Love* (1963), were enormously successful. They adroitly combined instruction with thrills – hints as to the best vintage year for the best champagne, followed by several pages of brutality. Ian Fleming, Bond's creator, came from an upper-class background but hit on just the right strategy in distancing himself from that world yet retaining a touch of aristocratic *usage du monde*.

James Bond's imitators – Boysie Oakes, Napoleon Solo, Matt Helm – were less men of the world than the original but their attractiveness to women was stressed every bit as much, almost as if it were an essential qualification for the job. This may have been necessary in box-office terms; by contrast, the spies whose names cropped up in real life were as often as not homosexual. The professional spy had always been rather an equivocal figure, useful but slightly despicable. John Buchan's Richard Hannay had been careful never to compromise his amateur status. With the novels of Len Deighton and John Le Carré, successors to Ian Fleming, the spy again became seedy and furtive, yet he was never again actually contemptible. Ian Fleming had played his part in making the role of secret agent a desirable one, rather as others had done for photographers and hairdressers.

The Sixties said to hell, too, with the old idea that you had, if not to be out of the top drawer, at least to act as if you were once you'd arrived. The typical Sixties successes were very much not out of the top drawer. More interestingly, few ever bothered to seem so. It is not the least of Patrick Lichfield's achievements that he has overcome the terrible handicap of his background and become accepted by David Bailey and Mick Jagger.

So far the Sixties has been discussed in British terms. But the vehicle that bore Marsha Hunt aloft to fame was an import to Britain from the United States. There were others: flower power, pot-smoking, rhythm and blues. The movement of fashion was two-way, however, which is why *Lichfield in Retrospect* is a picture gallery whose halls extend either side of the Atlantic. The Sixties was the first decade in which large-scale interaction between British and American culture became normal. This is partly because it was the first time that transatlantic travel was widely affordable, partly because of the increasing pervasiveness of television. Whatever the fundamental cause, Patrick Lichfield was for a time in the late Sixties one of Britain's most distinguished exports to the United States. (This was an era when the British were urged to export – or die.)

Patrick Lichfield was not the first young man to take Horace Greeley at his word and try stepping out in a westerly direction. The Beatles, the Stones and David Frost had all gone on ahead. Other cultural goods sent across included television programmes – *Danger Man* (with Patrick McGoohan), *The Avengers*, *The Forsyte Saga*. This may seem

to overemphasize show business, with its tendency to concentrate on the visual, but the visual was a predominant quality of the age.

The Sixties in the United States was less obviously the decade of youth. True, it started with the ascendancy of John Kennedy, who was undeniably young – for a president. After 22 November 1963, however, it was a veteran of the smoke-filled rooms who took over. And the bloodletting that occurred with distressing frequency throughout the rest of the decade had as its victims mostly young people, whether in Vietnam, at Chappaquiddick with the drowning of Mary Jo Kopechne, or in Hollywood with the mutilation of Sharon Tate. When youth did adopt an active role, as with the events starting at the 1968 Democratic Party Convention and culminating in the trial of the Chicago Seven, the only result was the decade's being seen out by Richard Nixon, a retread tyre given his eight years as vice-president in the Fifties.

The United States had a theoretical advantage over Britain in launching the Sixties: her great strength lay in being much less in thrall to a glorious past. In Britain as late as 1964 the incumbent prime minister was the third successive Old Etonian to hold the office. It seemed to many that he had been chosen by mystical processes more suitable for study by the anthropologist than by the political scientist. The first of the triumvirate had been the brother of a baronet; the second the brother-in-law of a duke; the third a disclaiming earl. If the BBC had sold *The Pallisers* to the United States at that time instead of a decade and a half later, the Americans would have been justified in regarding the series as the last word in up-to-date statements about the modern British body politic.

Politics was not the only fossilized life form. Page one of *The Times* in the early Sixties contained nothing more germane to current affairs than the personal column. Only in 1967 were steam engines, those most characteristic products of Britain's nineteenth-century industrial glory, finally withdrawn. As late as 1960 it had even been officially implied that *Lady Chatterley's Lover* was not the kind of book you would let your servants read. (To some the most piquant aspect of this attack is the assumption that everyone still had servants, to others the notion that the employer could ever exercise *droit de seigneur* over his servants' reading matter.) How swiftly things changed. By New Year's Eve 1969 the fourteenth Mr Wilson (Lord Home's only memorable witticism) was finishing the second of his four terms of office; there were to be no more OE PMS for the foreseeable future; *The Times* had relegated its personal column to the inside and in pursuit of readers was undergoing the first stage of its transmogrification to something nearer a popular daily; steam engines were now only to be seen on private railways, such as the Bluebell Line, or in museums. Concorde was the latest concept in transport. Indeed the talk for some years had been of technology, specifically the 'white heat' of the scientific revolution in terms of which Harold Wilson had claimed in 1963 to redefine socialism. Kenneth Tynan with a single rude word had relegated the *Lady Chatterley* question to the background. There was little point in hunting for smutty language in print when it was spoken on television. Finally, Selective Employment Tax had emptied the servants' hall of its last loitering occupants.

So when Britain did get around to launching the Sixties she overtook

the United States in a single bound. The young proved too much for their parents. Nothing quite so drastic happened in the States, where the greater size of the hinterland and the greater hold of religion on the people militated against a *coup d'état* by youth. It would be facile to pin the moment Britain accomplished her great leap forward, or even American recognition of the fact, to the spring day of 1966 on which *Time* published its 'Swinging London' article, though this is sometimes done. The Americans had welcomed the Beatles a couple of years earlier, with all the sudden ecstasy they are capable of. Moreover, a New York magazine had commissioned photographs of fashionably oscillating Britons from Patrick Lichfield as early as the summer of 1965.

The repression of youth in Britain was so great before the Sixties that the country can be said to have joined the twentieth century only then. Because of the forces pent up by a truly formidable old guard, however, things moved, when they did move, with rapidity. The Sixties brought about a revolution in Britain – not the 'infantile disorder' of 1968, as Lenin once described 'left-wing communism', but the more subtle and drastic undermining of a set of assumptions in the high revolutionary period from 1964 to 1970. It was a social revolution in the purest sense of the word: politics hardly came into it.

The world we live in today is essentially that shaped by the Sixties. It is in architectural terms that the decade's legacy – the result of despoliation committed by developers and town planners in the name of modernity – seems irreparably ruinous. The new Euston station which occasioned the destruction of the old Euston Arch is one example, and insult was added to injury with the discovery that the new station was deliberately designed without seats.

This is not to say that from the point of view of human rather than architectural spectacle the Sixties wasn't enormous fun. There was an innocence about it which today we regard wistfully. We have seen how easy-going indulgence in marijuana has been replaced by an appalling vulnerability to cocaine and heroin, how cheerful irreverence towards experience and tradition has been transformed into surly lawlessness. But there is no reason to deplore the carnival atmosphere along with the disillusionment which has succeeded it. For one thing, it is not even certain that the former entailed the latter. The frivolous 1920s led not to accelerated hedonism, but to the sober 1930s. Earlier still, Regency laxity gave way to Victorian primness. The Eighties may be wiser than the Sixties, hence less exuberant, but there is no law against a moderate indulgence in nostalgia. Nothing is quite so poignant as yesterday's fashionable enthusiasm. Few eras are so absolutely poignant as the one that played host to such a variety of fashionable enthusiasms. That Was The Sixties, That Was.

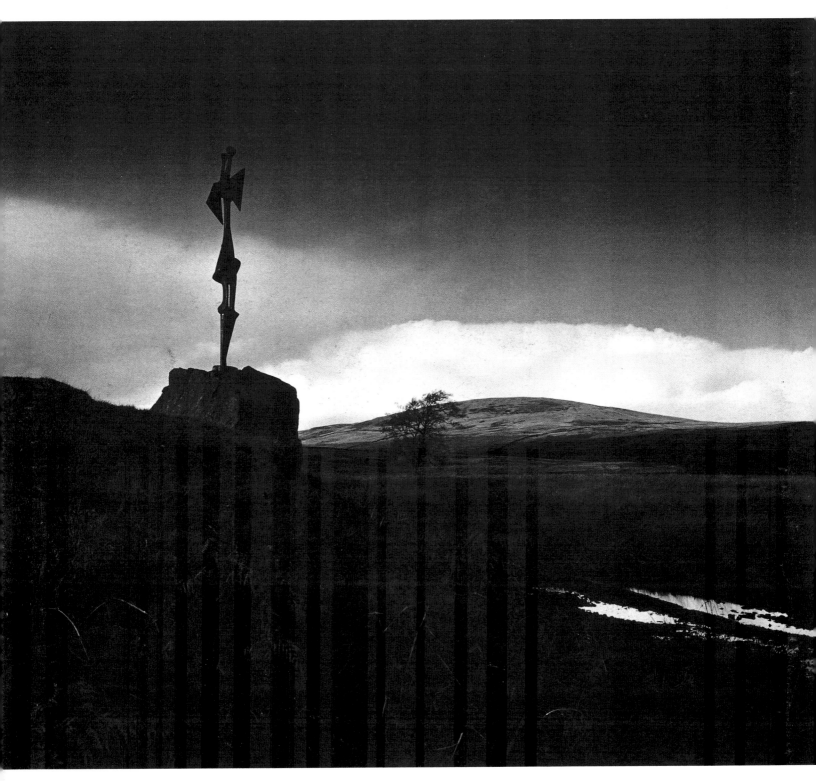

'Standing Figure, 1950' by Henry Moore, Glenkiln, Dumfries-shire, 1963

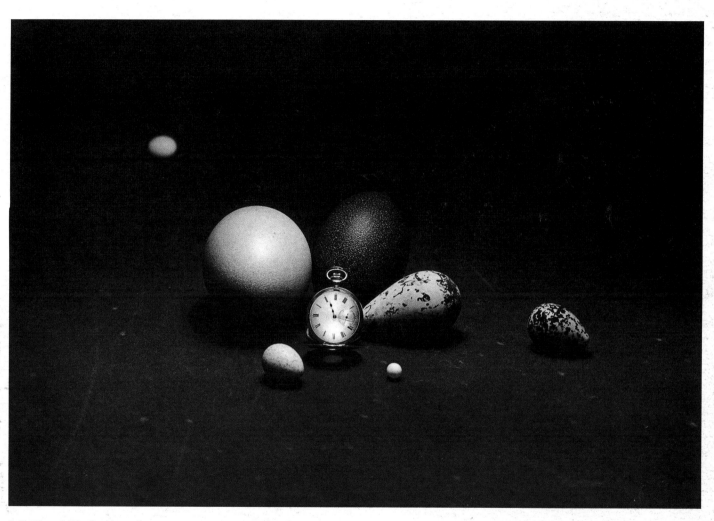

Still life on billiard table, 1964

Serena Russell, whose photograph here was taken at her coming-out ball at Blenheim Palace, is the niece of the Eleventh Duke of Marlborough. No one unfamiliar with the tempo of life at Blenheim would ever believe the Serena Russell picture was wholly of the real world. It has so many of the dreamlike features – opulently dressed figures in a landscaped setting – appropriate to a film such as *Last Year in Marienbad* (1961), or at the very least an advertisement for one of the superior brands of chocolate. In short, such an archetypally ducal ambience from the early Sixties seems as surrealist to modern sensibilities as the non-representational sculpture set in Scottish moorland, pictured on page 22. Yet that too has an authentic existence apart from the whimsies of the art director and photographer who usually choose such subjects, being one of a number of Henry Moore and Epstein works that Anthony Keswick has installed on his Scottish estate near Dumfries. The Keswick family are proprietors of the Far Eastern mercantile house of Jardine Matheson – such people used to be called taipans.

The billiard balls, eggs and watch on page 23 make the most palpably Daliesque composition of the book. They too have a Scottish setting – the billiard room at Brechin Castle in Angus, which is Lord Dalhousie's seat and the home of Lady Elizabeth Ramsay, Patrick Lichfield's first assistant.

Serena Russell, Blenheim Palace, Oxfordshire, 1964

Countess Beatty, Chicheley Hall, Buckinghamshire, 1967

Lady Beatty, daughter-in-law of the Admiral Beatty who commanded the battle cruisers of the British Grand Fleet at the Battle of Jutland in 1916, was photographed at her country house, Chicheley Hall in north Buckinghamshire. Both she and the girl who follows, Lulu de la Falaise, seem to be treading on air. The Sixties was like that.

Lulu (sometimes spelled Loulou) de la Falaise was a design assistant to Yves Saint Laurent, whom she also backed financially. She married the Knight of Glin (one of only three Irish hereditary knights) in 1966. Whereas Lulu de la Falaise came from a titled family and became involved in fashion, Sally Croker Poole, pictured on page 28, was a professional model who subsequently married into the social stratosphere. Her first husband was Lord James Crichton-Stuart, younger brother of the Marquess of Bute and a director of Coutts the bankers; her second is the Aga Khan. Tinka Paterson, with whom Sally Croker Poole is seen here, was a leading male model of the Sixties.

Jill Kennington, on page 29, is perhaps more a model's model; her image frequently appeared in *Queen*.

Lulu de la Falaise, New York, 1969

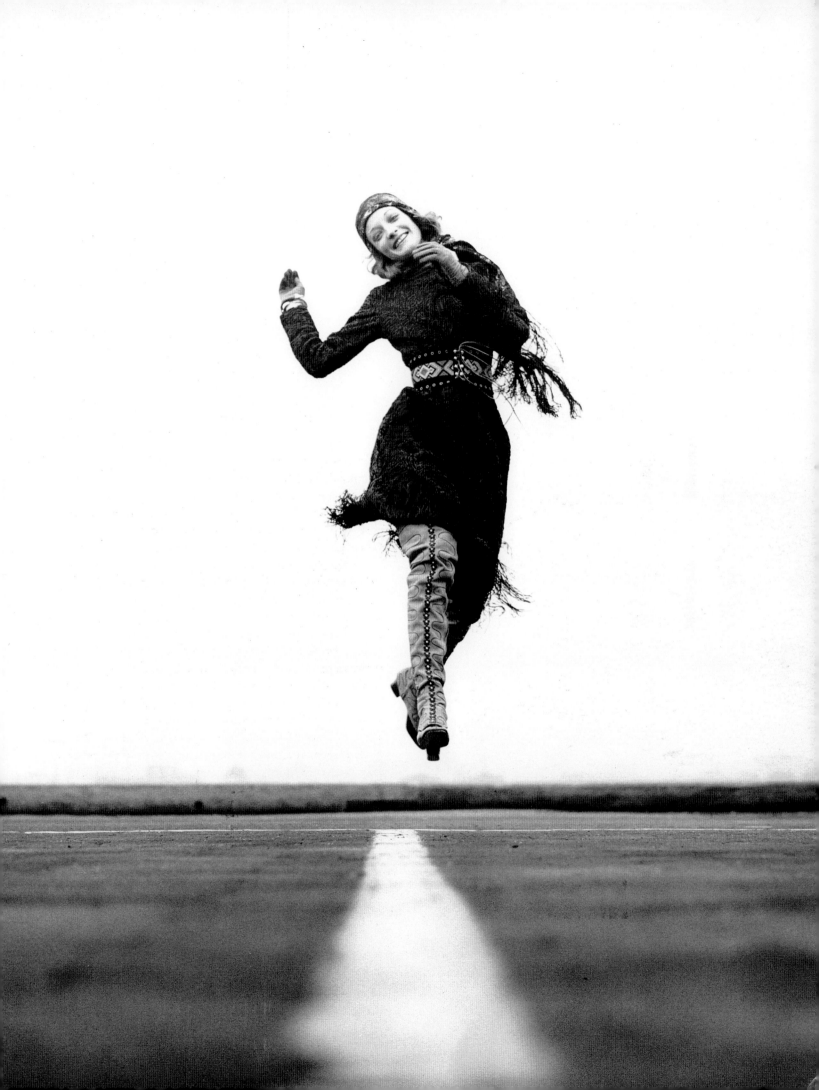

Sally Croker Poole and Tinka Paterson, Ascot, 1965

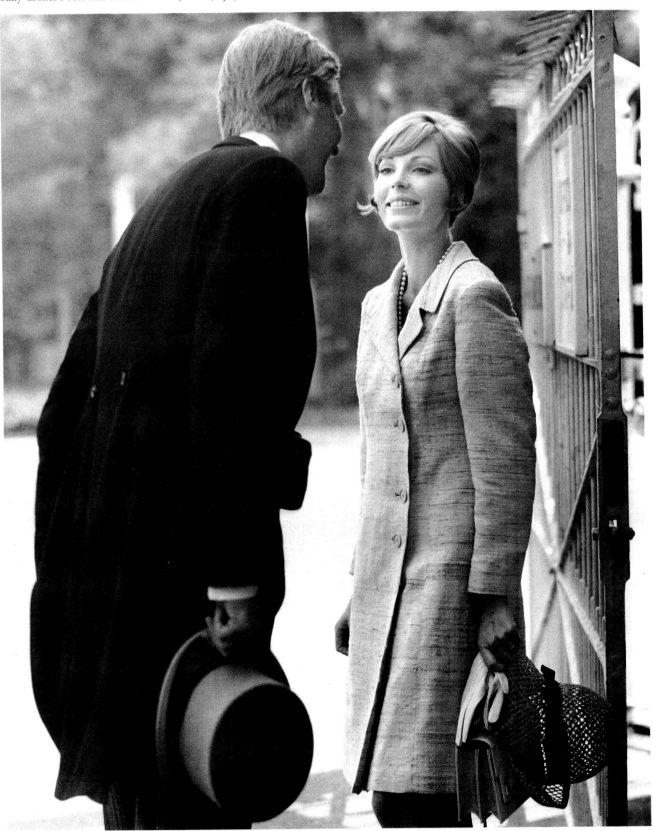

Jill Kennington, Belgravia Mews, London, 1964

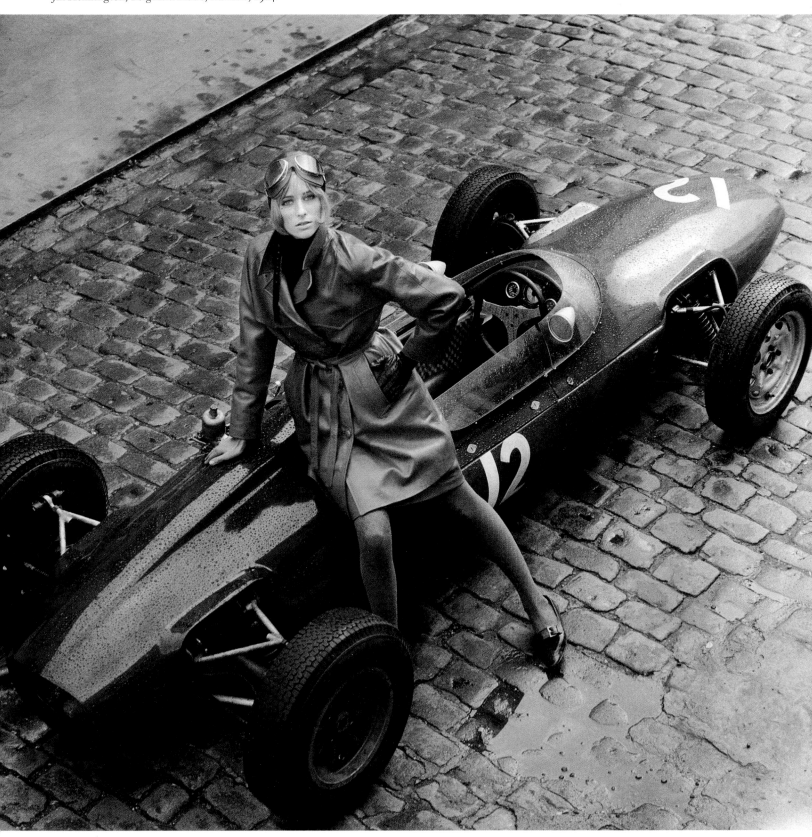

Sybilla Edmondstone is the fourth and youngest daughter of the late Sir Archibald Edmondstone, Bart. Her mother was the daughter of Marshall Field, of Chicago, making her one of those interesting blends of the Old World and the New of which Sir Winston Churchill, Harold Macmillan and Lord Hailsham are other examples. In the Sixties a nightclub in London, Sybilla's, was named after her. The only other person to be honoured on the same scale in modern Britain has been Lady Annabel Goldsmith, after whom Annabel's is named.

Celia Hammond, although like Sybilla Edmondstone an essentially Sixties figure, was a Fifties discovery – just.

It was Norman Parkinson who spotted her in 1959 when the Lucie Clayton fashion agency staged a 'cattle market' parade of their models. He immediately snapped her up and photographed her for the front cover and inside pages of *Queen*. Jocelyn Stevens, *Queen*'s owner, was equally enthusiastic. Subsequently she became one of the leading models of the Sixties; by the Eighties she was writing about the protection of animals for *The Times*. The butterfly dress she wears in the picture repeats a theme very popular towards the end of the Sixties – rather as the pierrot was in the Twenties. The butterfly, a decorative, ephemeral, fragile creature, was an apt icon of the times.

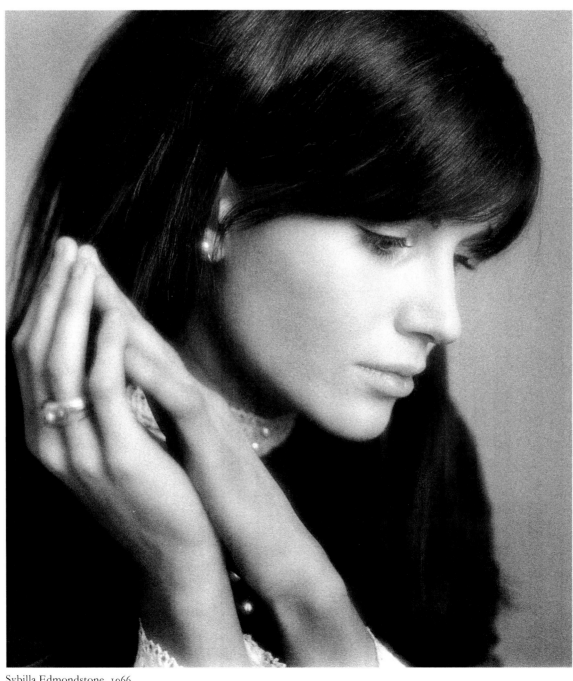

Sybilla Edmondstone, 1966

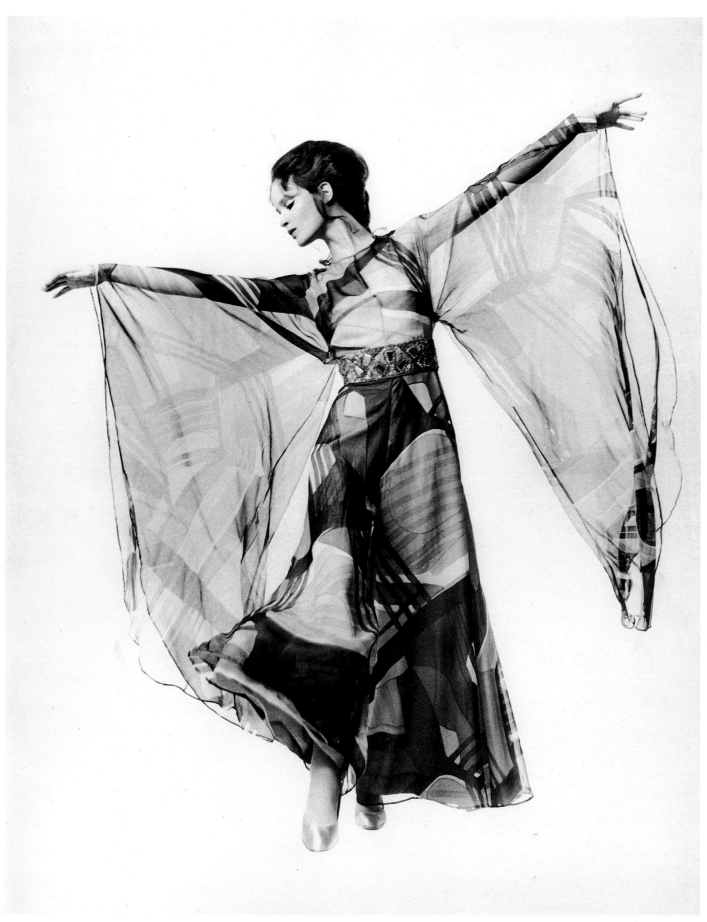

Celia Hammond, 1968

Jacqueline Bisset, Wilton Place, London, 1964

Astrid Heeren, Jamaica, 1966

Jacqueline Bisset, here looking apprehensive in a London mews, has usually acted in films with more exotic settings: *Bullitt* (1968), where she played the lover to Steve McQueen's San Francisco policeman; *Airport* (1970), which was made long enough ago for the idea of air travel to retain some smidgen of glamour in itself; *Murder on the Orient Express* (1974), set in a snowdrift; and *The Greek Tycoon* (1978), where she received star billing as the Jackie Kennedy figure opposite Anthony Quinn as the Onassis figure. The first film she appeared in, however, was *The Knack* (1965), one of the earliest of Richard Lester's attempts to capture Swinging London on celluloid.

Astrid Heeren, a less well-known actress than Jacqueline Bisset, has had small parts in *The Thomas Crown Affair* (1968) and a James Bond film, while Tsai Chin, also an actress, was a figure on the edge of the Chelsea Set, which merged in the Sixties with the rather larger, less cohesive cast of Swinging London.

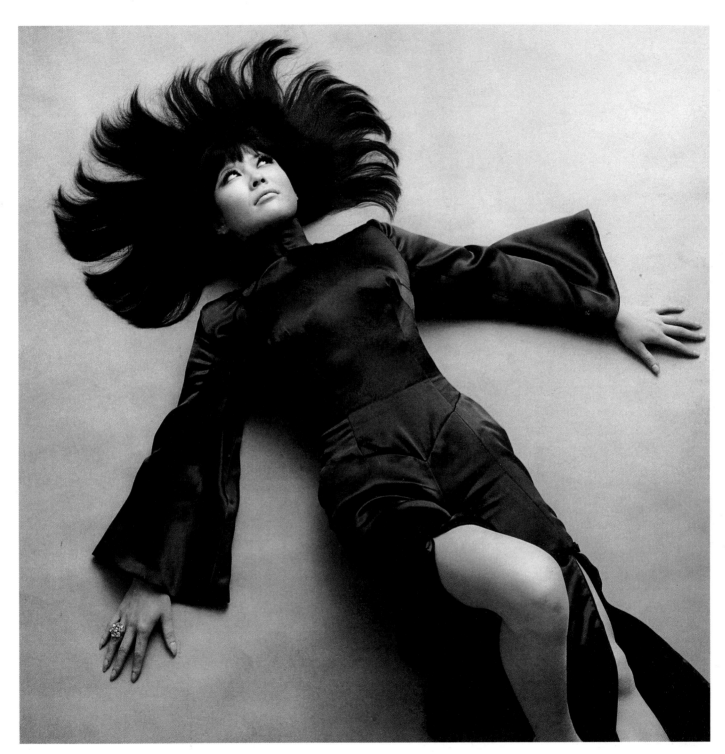

Tsai Chin, 1966

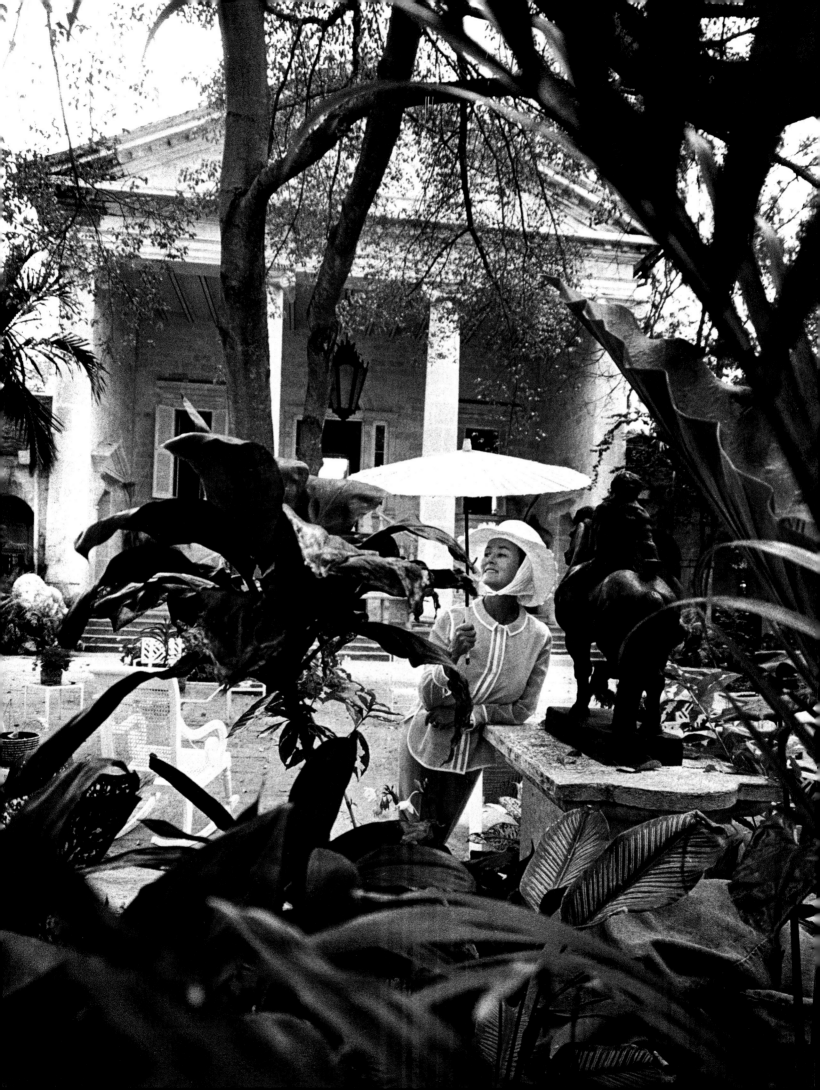

Marietta Tree, Barbados, 1967

Zsa Zsa Gabor, Mayfair, London, 1965

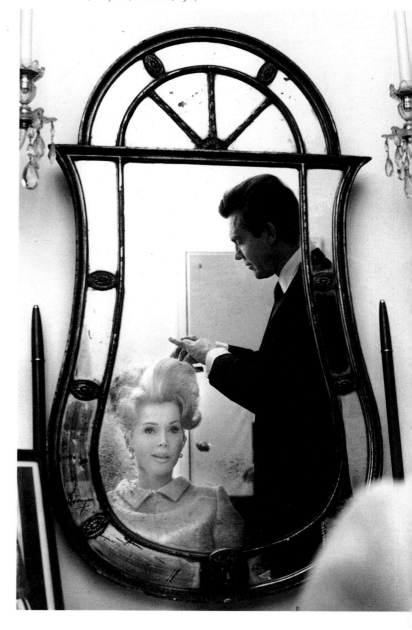

Marietta Tree is an American who married the former
Conservative MP, Ronnie Tree. Their daughter Penelope
was one of the leading models of the Sixties. Marietta Tree
is seen here in the grounds of her house in Heron Bay,
Barbados.

 Zsa Zsa Gabor, although conventionally described as
an actress, is more famous for simply being herself. She has
appeared on innumerable television chat shows, where she
deploys her unreconstructed Hungarian accent to
devastating effect. She was Miss Hungary in 1936 and
played Minerva, a Batvillain, in the Batman television
series of the Sixties. She was also the recipient of largesse
from the late General Rafael Trujillo, dictator of the
Dominican Republic. The gentleman attending to her hair
is René of Mayfair – a deliciously Sixties name, evocative
of an age when anything at all to do with beautification
was as French as possible.

Of the British actresses who emerged in the Sixties Susannah York has lasted particularly well. Her films are among the better examples of what the industry can do: *Tom Jones* (1963) won an Oscar for best picture and *They Shoot Horses, Don't They?* (1969) won her an Oscar nomination for her performance as Alice. In the Sixties she briefly became a martyr to fashion when she was refused entrance to the Colony Restaurant in New York on the grounds that she was wearing a trouser suit rather than a dress.

Susannah York, Rabat, Morocco, 1967

Angie Crewe and daughter, Bedfordshire, 1967

Angie Crewe and her daughter Candida belong to one of
the great Liberal dynasties of Britain. They are respectively
the second wife and daughter of Quentin Crewe, the food
writer, and were photographed as part of a series of
mother-and-daughter shots. Quentin Crewe is descended
not just from the Marquess of Crewe, secretary of state for
India and lord privy seal under Asquith, but also from Sir
James Graham, who was First Lord of the Admiralty
under Lord Aberdeen at the time of the Crimean War.
Angie Crewe is better known as a writer under her maiden
name of Angela Huth.

Leslie Caron and her daughter were photographed
for the same series. Leslie Caron is probably best known
for her part as Gigi in the film of the same name (1958), for
which that other celebrated photographer Cecil Beaton
was production and costume designer.

Leslie Caron and daughter, 1968

The Hon. Nicholas Beatty, Chicheley Hall, 1967

Boy on train to Scotland, 1963

Nicholas Beatty is the son of Lady Beatty and the late Lord
Beatty. The setting for this picture was again Chicheley
Hall – a fine example of English baroque architecture with
the front door a copy of a feature in Bernini's Chapel of the
Holy Crucifix in the Vatican.

A similar cross-legged pose is held by the boy in the
train. Taken on a journey to Scotland, the picture is a
nostalgic reminder of the charm of Sixties railway
transport as depicted so memorably in innumerable Ealing
comedies. Such well-upholstered rolling-stock is still to be
found on the Bluebell Line.

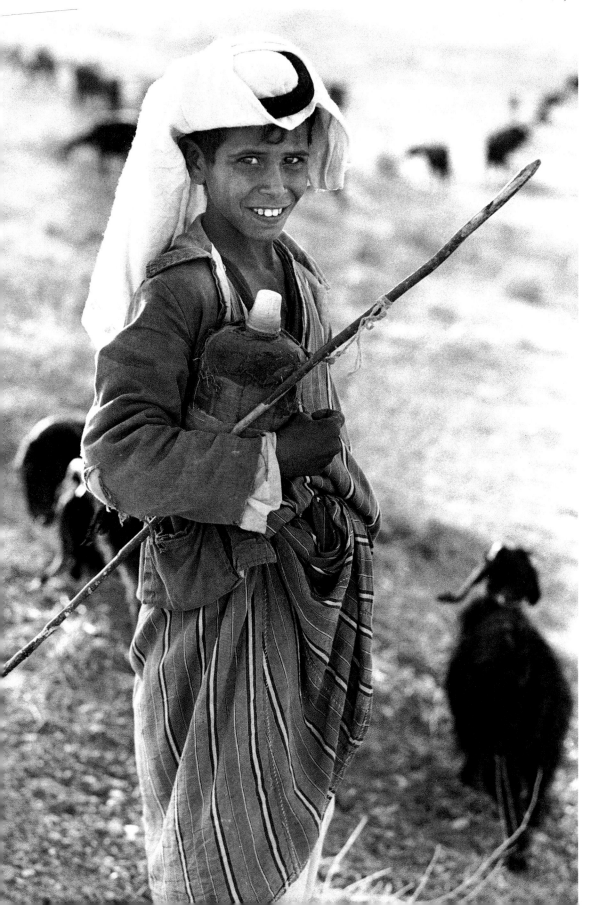

Goat-herd, Israel, 1966

Bahamas, 1967

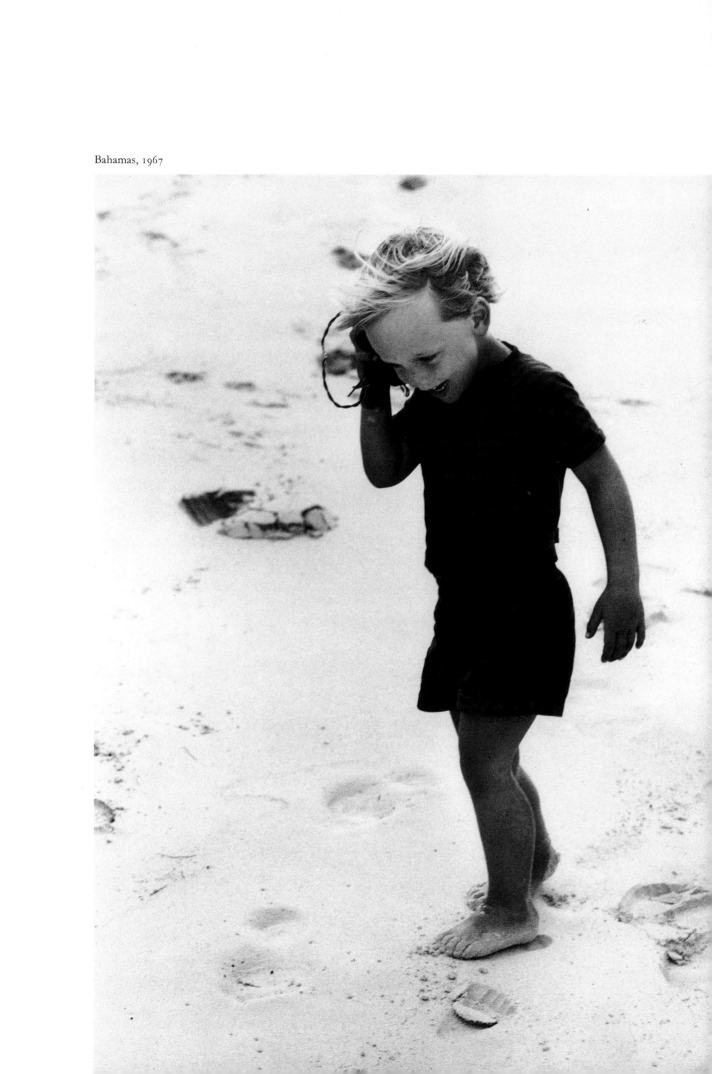

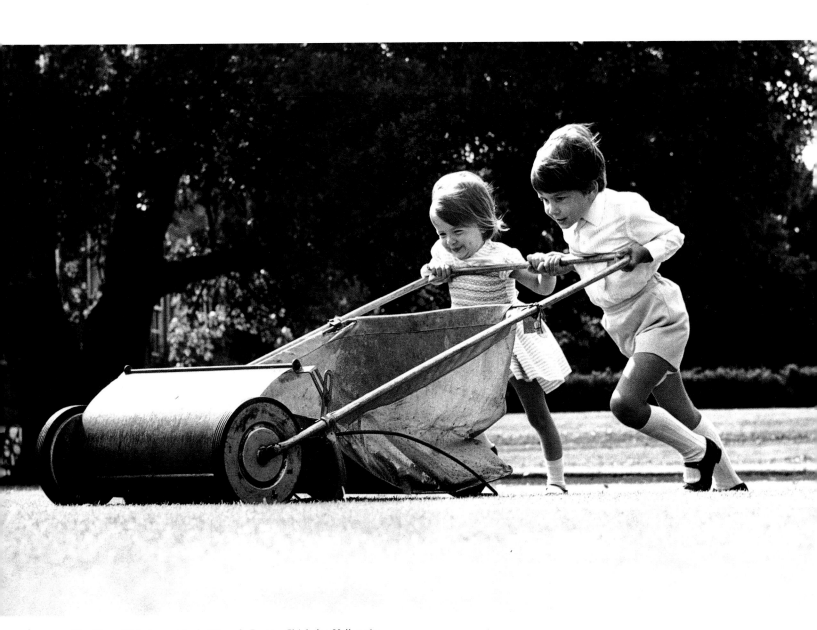

The Hon. Nicholas and Lady Miranda Beatty, Chicheley Hall, 1967

The picture of the two children sweeping the lawn – Nicholas Beatty and his sister Miranda – was one of a series of child photographs taken for parents in the Sixties while Patrick Lichfield was establishing his professional reputation.

The most contemplative of the child shots is that of Cary Elwes, one of the portraitist Dominick Elwes's sons and now an actor in his own right. He played the hero in William Goldman's tongue-in-cheek fairy-tale film, *The Princess Bride* (1988).

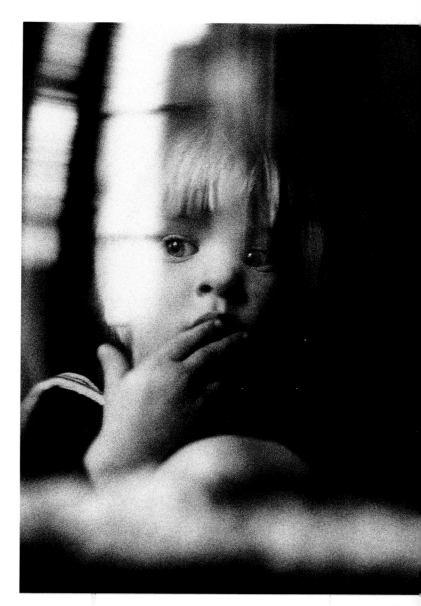

Cary Elwes, 1965

The Earl of Yarmouth, Ragley Hall, Warwickshire, 1964

The Earl of Yarmouth is the only son and heir of the Eighth Marquess of Hertford. The photograph was taken at Ragley Hall in Warwickshire, Lord Hertford's seat.

There used to be a saying among worldly dowagers that went, 'Always be polite to young girls. You never know who they may marry.' The little girl in striped shorts became Patrick Lichfield's cousin by marriage almost a quarter of a century after the picture here was taken. At the age of four Sarah Ferguson already shows something of the tomboy readiness to try anything that led her to attain her wings as a pilot only a few months after marrying Prince Andrew.

Sarah Ferguson, Dummer, Hampshire, 1963

Philip Dunne, Gatley Park,
Herefordshire, 1963

Boy and dog, Islay, Inner Hebrides, 1963

Philip Dunne is pictured here as a small boy of five, as camera-shy then as he is now.

The boy looking out of the window with his dog is a grandson of Lord Margadale, the last hereditary peer to be created before the twenty-year moratorium on hereditary peerages that ended only with the creation of the Stockton earldom and the viscountcies of Whitelaw and Tonypandy in the mid Eighties. Lord Margadale's family name is Morrison, and the Morrisons have thrown up at least one MP in every generation since before the Great Reform Bill. They remain firmly entrenched in the upper reaches of the Conservative Party.

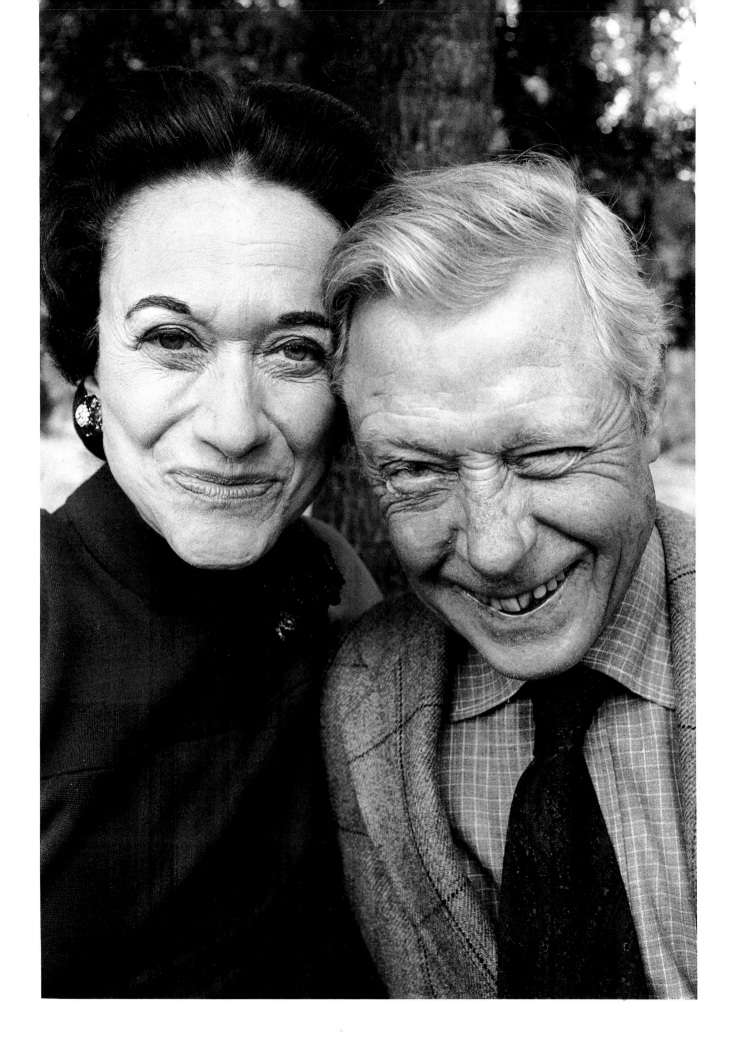

Portrait photography is still conventional enough to make the smile a bonus. And yet it becomes more and more difficult to think up ways to get subjects to smile, particularly if they have been photographed all their lives. It says much for Patrick Lichfield's improvisatory skills, sharpened to Nelson Touch acuteness by his Army training, that he ever managed to coax such grins from the Duke and Duchess of Windsor. He clambered on a weakly upholstered chair, fell through it – as he had anticipated he would – and instantly got the picture he wanted.

David Mlinaric has been one of Britain's most fashionable interior decorators for a quarter of a century. He married Martha Laycock, whose grandmother, Mrs Dudley Ward, was closely associated with the Duke of Windsor when he was still Prince of Wales. The prince rather abruptly threw her over after meeting Mrs Ernest Simpson.

David Mlinaric, 1966

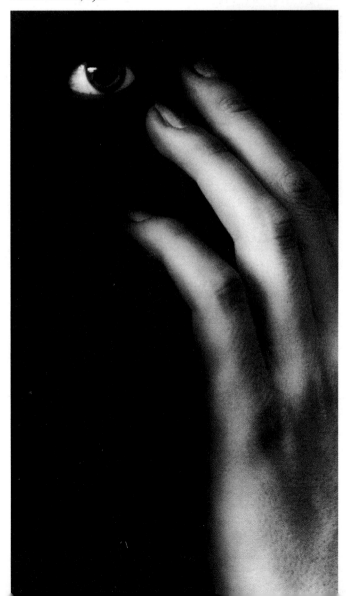

The Duke and Duchess of Windsor,
Moulin de la Tuilerie, near Paris, 1967

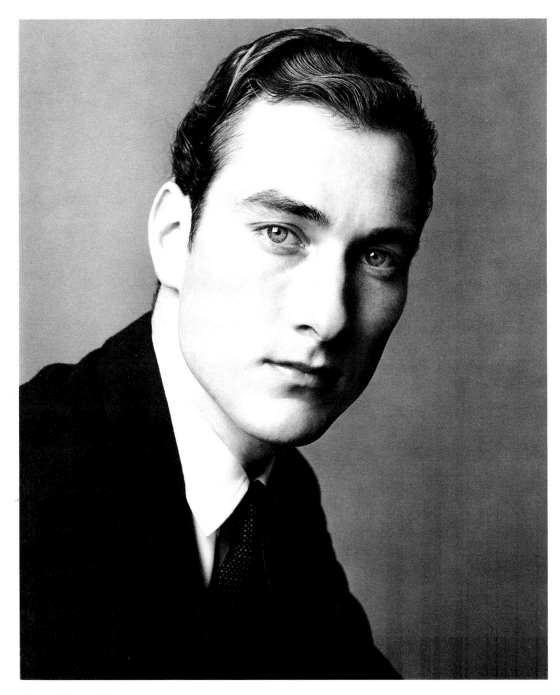

Prince William of Gloucester, 1965

Prince William of Gloucester was the elder son of the late
Prince Henry, Duke of Gloucester, a younger son of
George V. He joined the Commonwealth Relations Office
in 1965 and continued with the Foreign and Commonwealth
Office after the CRO merged with the FO, serving
en poste at Lagos in Nigeria, and in Tokyo. Sadly, he was
killed in a flying accident in 1972.

Compared with the Windsors, Prince Claus of the
Netherlands was easy to photograph smiling, since the
session coincided with the day his eldest son, Prince
Willem-Alexander, was born. He is the German-born
husband of Queen Beatrix of The Netherlands.

Prince Claus of the Netherlands, 1968

The Hornby-Cazalet wedding took place between Simon Hornby, now chairman of W.H. Smith, and Sheran Cazalet, daughter of the racehorse trainer Peter Cazalet. Sheran Cazalet's mother was a stepdaughter of P.G. Wodehouse. A fine collection of guests attended, among them the galaxy of distinguished persons visible in the picture.

Lord Lovat is the seventeenth holder of the title. His ancestor, the Eleventh Lord Lovat, was attainted after the 1745 Jacobite uprising, although the act of attainder, which involved forfeiture of the title, was reversed in 1857. The present Lord Lovat's younger brother Sir Hugh Fraser was a Conservative MP and husband for a while of Lady Antonia Fraser. Lord Lovat is seen here in front of Beaufort Castle, his seat in Inverness-shire.

Early in 1988 Lord Eliot inherited his father's earldom of St Germans. At the time this picture was taken he lived *la vie de bohème* in the King's Road. The family estates lie farther west, in Cornwall.

Lord Lovat, Beaufort Castle, Inverness-shire, 1967

Lord Eliot, 1963

Hornby-Cazalet wedding: *(left to right)* Elizabeth Taylor, Noël Coward, Sheran Cazalet, Richard Burton, Princess Margaret, 1968

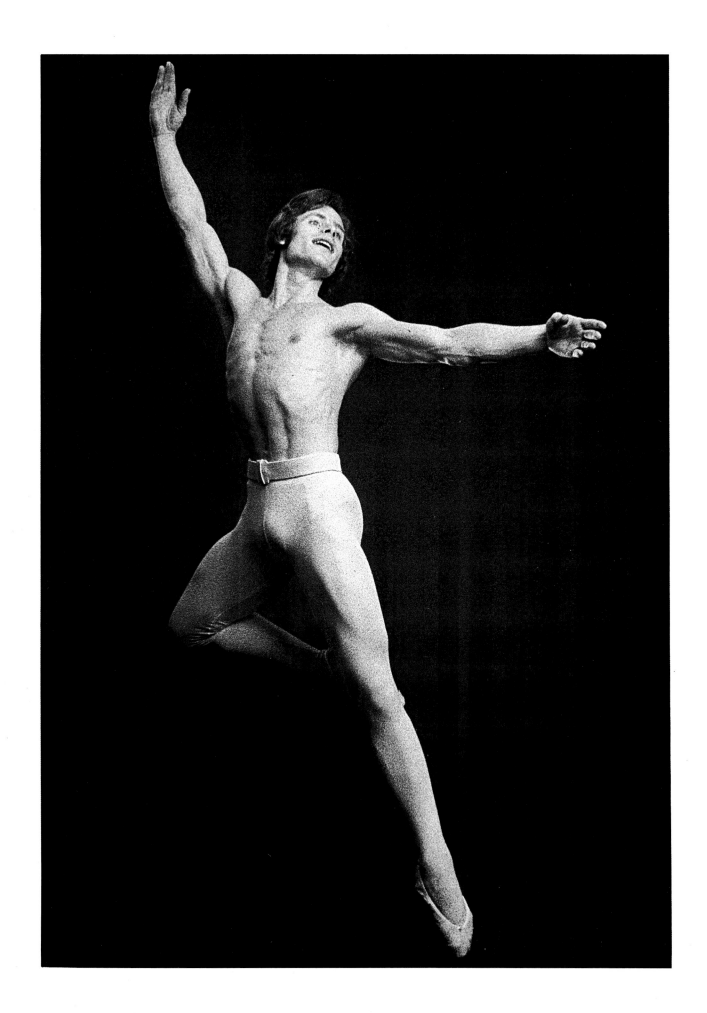

David Wall, 1969

David Wall is now director of the Royal Academy of Dancing. He was formerly senior principal dancer of the Royal Ballet, during which period he created roles in Kenneth Macmillan's *Anastasia*, *Manon* and *Elite Syncopations*. Anthony Tudor choreographed *Knight Errant* especially for him. He is married to the ballerina Alfreda Thorogood.

Lord Lyell's dancing is undertaken in a less demanding milieu than the Royal Ballet, though Scottish reels can be exhausting enough. He is of authentic Scottish descent, which presumably helps. Outside the ballroom Lord Lyell is a government whip in the House of Lords. Like Patrick Lichfield he served in the Brigade of Guards during the late Fifties. The picture of him here was shot at Kinnordy Castle in Angus, where he lives when not active as a hereditary legislator at Westminster.

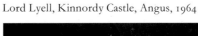

Lord Lyell, Kinnordy Castle, Angus, 1964

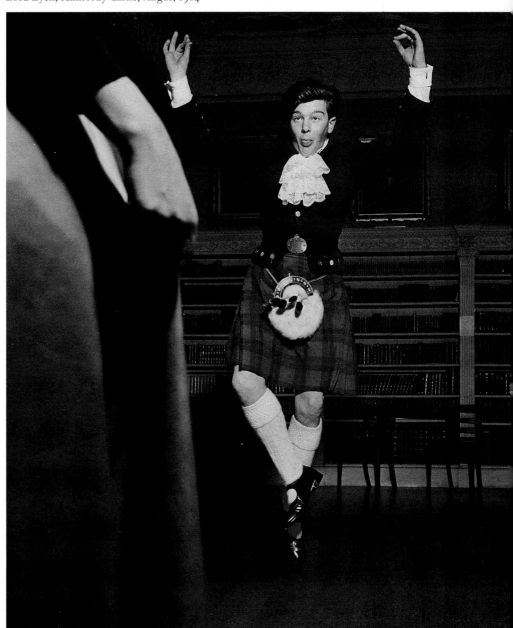

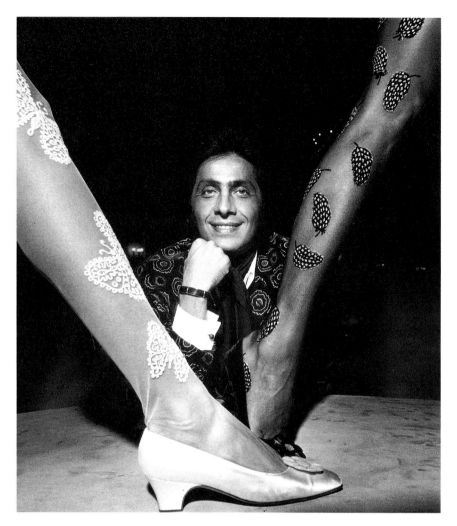

Valentino, Savoy Hotel, London, 1968

The Rome-based couturier Valentino was photographed at
the Savoy when he arrived with his new designs for tights
in the autumn of 1968. Note once more the butterfly motif
so characteristic of late Sixties iconography. It was
Valentino who in the mid Sixties helped make the trouser
suit for women acceptable when the stunning
seductiveness of a beige and white wool creation enticed
Jacqueline Kennedy into ordering one, thus giving it her
imprimatur.

The other great couturier of long standing, Yves
Saint-Laurent, was photographed in Marrakesh, in
Morocco, where he spends a large amount of time each
year between presenting his collections in Paris.

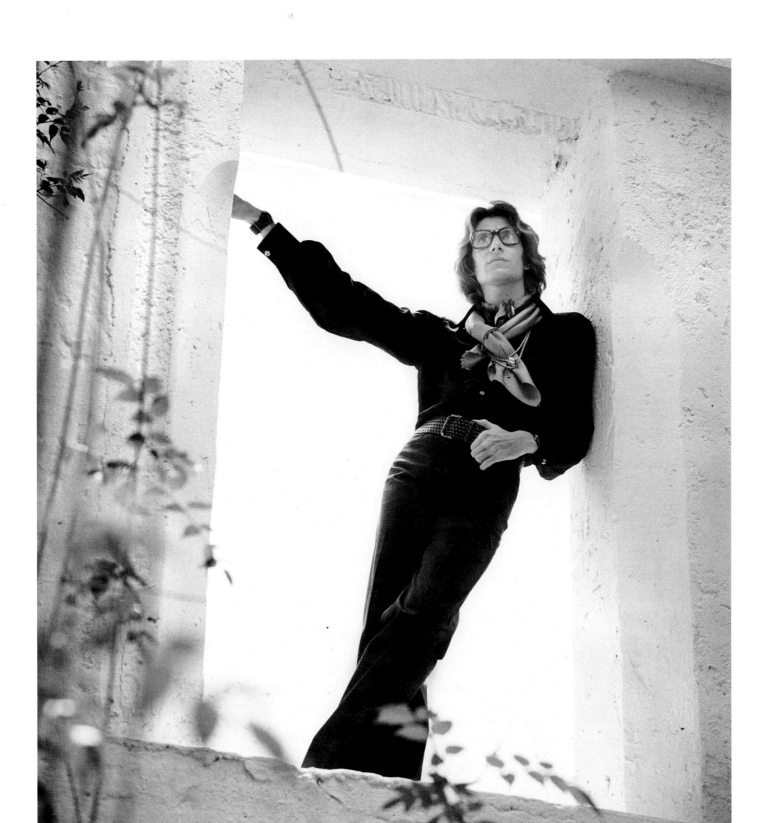

Yves Saint-Laurent, Marrakesh, 1969

Bryan Forbes, Wardour Street preview theatre, London, 1966

Feliks Topolski, 1969

Bryan Forbes is best known as a film director, with such works as *The L-Shaped Room* (1962), *King Rat* (1965), *The Wrong Box* (1966) and *The Stepford Wives* (1975) to his credit. He is the husband of Nanette Newmann and has also acted himself, appearing for instance in *The Guns of Navarone* (1961). In addition he wrote the screenplay for *Cockleshell Heroes* (1955) and *Only Two Can Play* (1962).

Feliks Topolski, the portrait painter, was photographed waving a torch. The idea was to create swirls of light to match his idiosyncratic brush strokes.

Charlie Chaplin and Marlon Brando were photographed at the Savoy in London when both were there for the première of *A Countess from Hong Kong* (1966), for which Chaplin wrote the screenplay and music. He also directed it. In addition to Brando and Chaplin the film starred Sophia Loren and Margaret Rutherford, but it received very poor notices.

Charlie Chaplin and Marlon Brando, Savoy Hotel, London, 1966

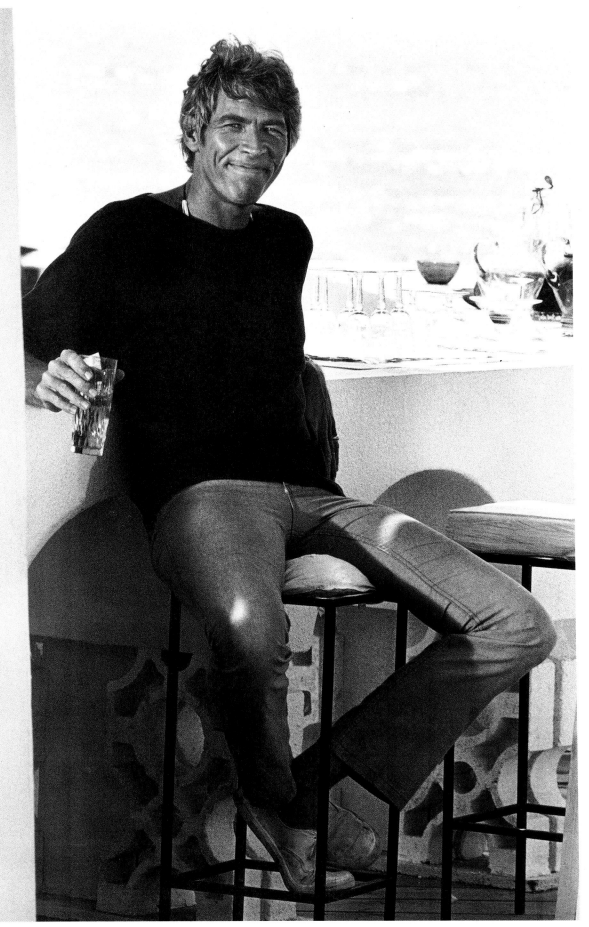

James Coburn, Almeria,
Spain, 1967

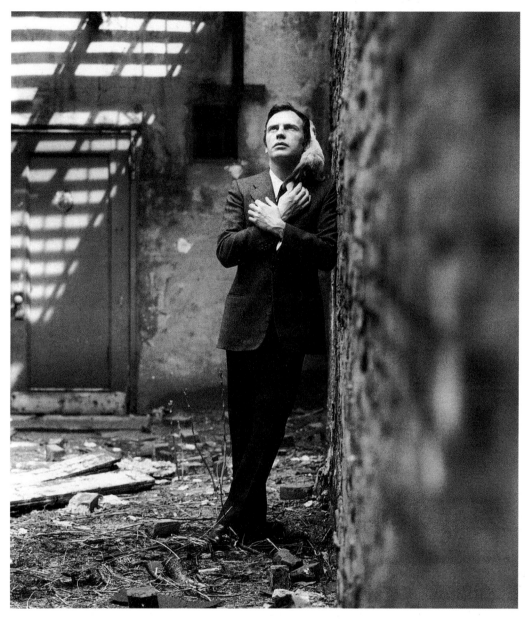

Jean-Louis Trintignant, New York, 1969

James Coburn first came to cinemagoers' attention as the knife-throwing cowboy in *The Magnificent Seven* (1960). He consolidated his reputation in the Sixties in *Our Man Flint* (1966) and *In Like Flint* (1967), two attempts to cream off some of the money generated by the James Bond bull market. Terrible though they were, he managed to rise above them. He later turned in a good performance in *The Street Fighter* (1975), or *Hard Times* to use its American title. The picture here was taken in Almeria in Spain during the shooting of *Duffy* – which also featured James

Mason, Susannah York and James Fox – in which two half-brothers try dishonestly to relieve their father of large quantities of money.

The French film star Jean-Louis Trintignant started with two overwhelming handicaps for a would-be actor. He had a heavy provincial accent and he was very shy. He has had good parts, however, in *And God Created Woman* (1956), *Is Paris Burning?* (1966), *Trans-Europe Express* (1967) and *Ma nuit chez Maude* (1969). He played opposite Anouk Aimée in *Un homme et une femme* (1966).

Françoise Hardy, 1969

Another French entertainer well known in the English-speaking world has been Françoise Hardy. In the mid Sixties she had three songs in the British hit parade, the most successful being 'All Over the World', which went as high as number sixteen and was in the charts for six weeks in 1965. An element of personal fragility in the singer, or perhaps a nostalgic quality in the sound, certainly had its appeal, though in real life she was rumoured to be quite tough and career-minded.

Tiny Tim's real name is Herbert Khaury. He was discovered in the United States, where he had been struggling along in Greenwich Village night spots for years, when he appeared on the television comedy show *Rowan and Martin's Laugh-In*. His most famous song was a falsetto rendering of 'Tiptoe Through the Tulips', in which he accompanied himself on the ukulele. 'Tiptoe' was superseded by an LP called *God Bless Tiny Tim*, which sold quite successfully. Shortly afterwards he married a seventeen-year-old girl on a mass-audience television programme, although his publicity agent stressed that the marriage was not consummated for at least the first three days of its existence. The couple separated in 1972, but Tiny Tim subsequently offered to take his wife back if she submitted to tests for venereal disease. In later years Tiny Tim, who was never particularly tiny anyway, put on considerable weight.

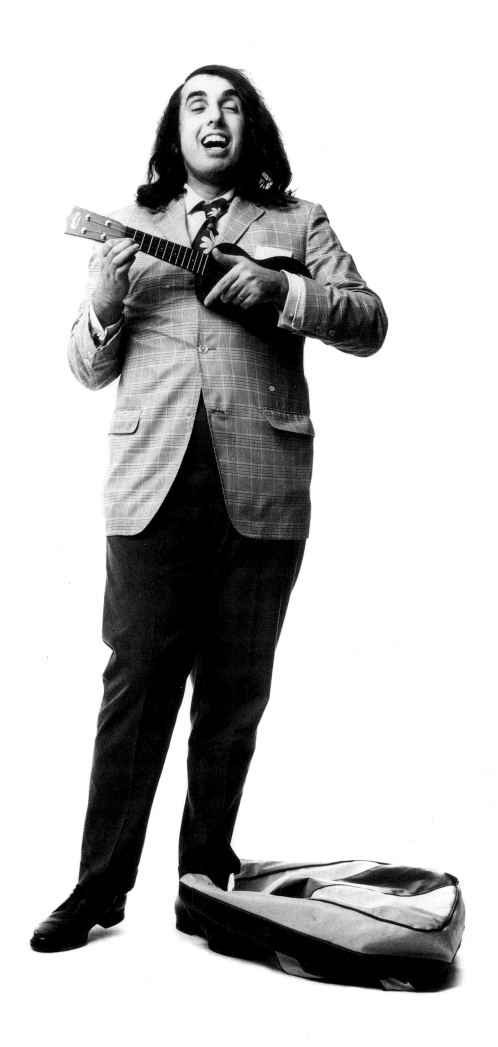

Tiny Tim, 1968

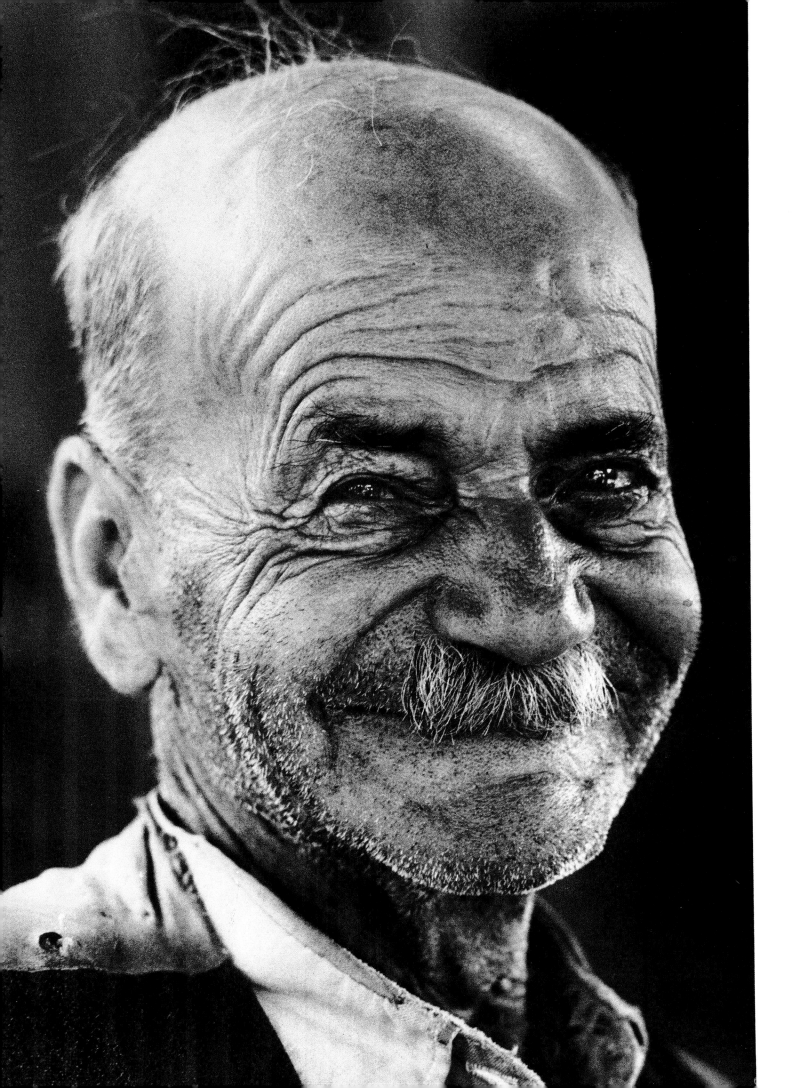

The picture of Jimmy Tarbuck was taken at a time when
Patrick Lichfield was under contract from Associated
Newspapers to photograph one interesting person a week.
Jimmy Tarbuck, the successful British comedian, started
in the north of England and still draws on northern
traditions, especially the working men's clubs, for much of
his material.

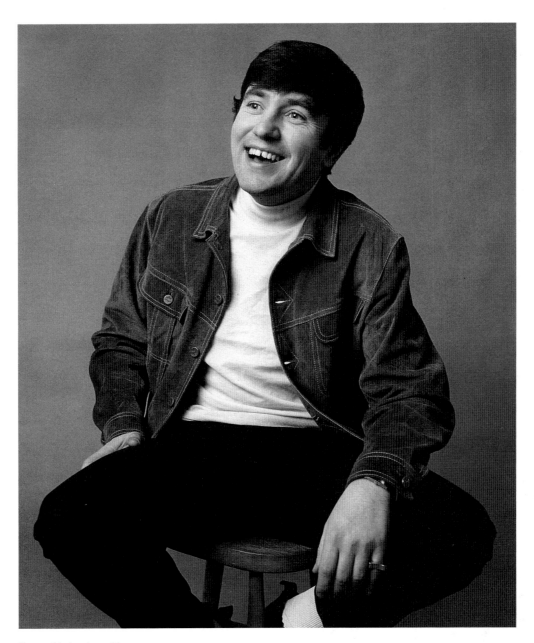

Jimmy Tarbuck, 1966

Old man, Cyprus, 1969

Henry Cooper, Thomas-a-Becket pub, Old Kent Road, London, 1966

Henry Cooper was British boxing's favourite son throughout the Sixties. He challenged Cassius Clay (as Muhammad Ali then was) for the world heavyweight title in 1963, when he gave a good account of himself before Clay was saved by the bell. He challenged Clay again in 1966, but was not so near winning this time. The referee stopped the fight in the sixth round when Cooper was bleeding heavily from cuts above the eyes.

Sir Harold Christie was a longtime resident and local legislator in the Bahamas, but his chief occupation was dealing in property.

Sir Harold Christie, Nassau airport, Bahamas, 1967

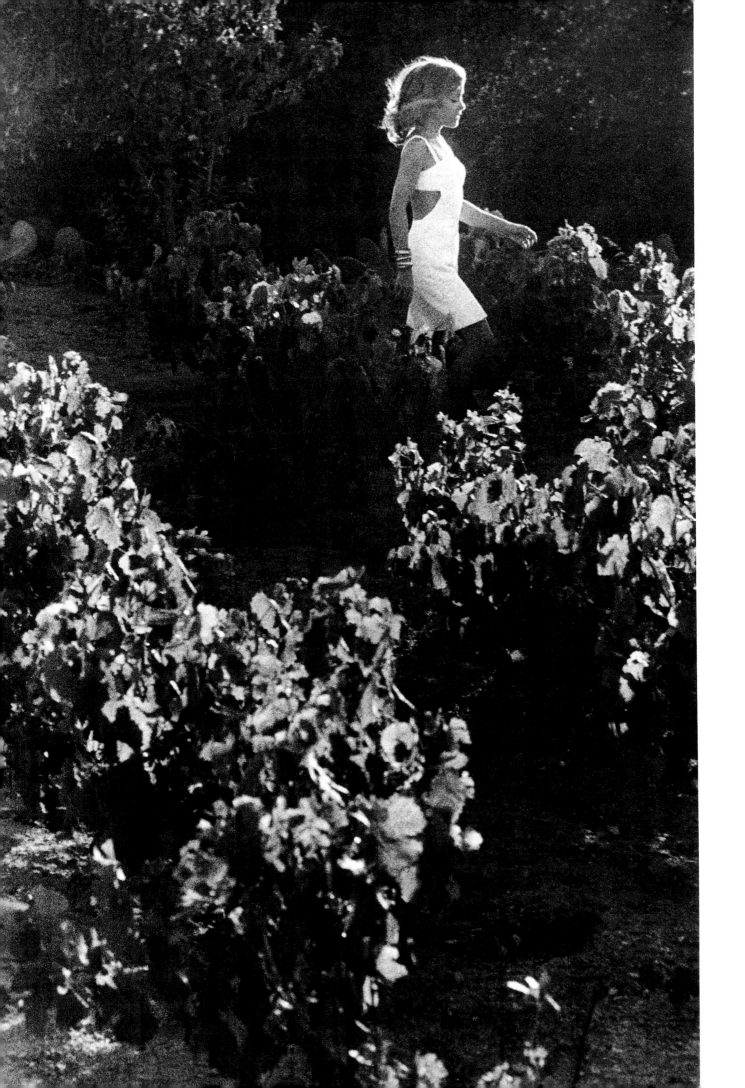

Sardinia, 1966

The shot of the girl in Sardinia was taken while Patrick Lichfield was on location to photograph the Aga Khan's Costa Smeralda development.

Desmond Morris was photographed soon after his enormously successful book *The Naked Ape* (1967) was published.

Desmond Morris, Malta, 1968

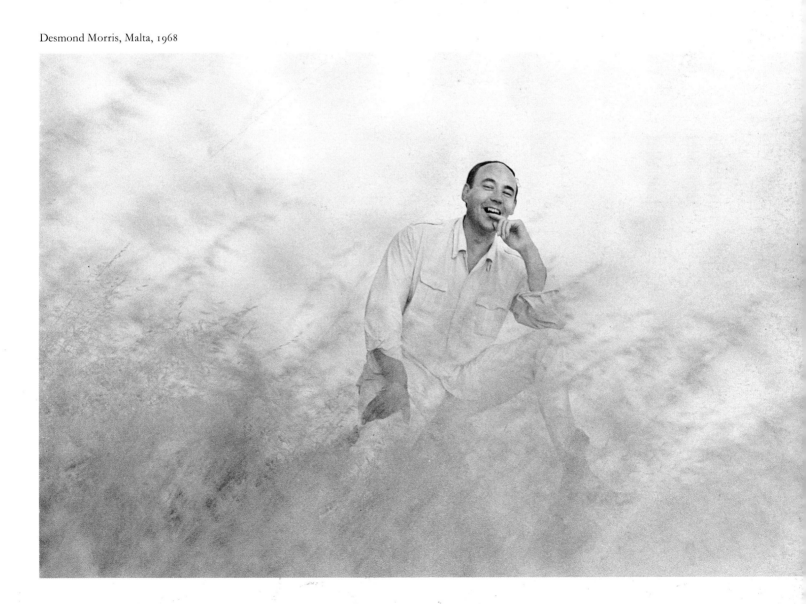

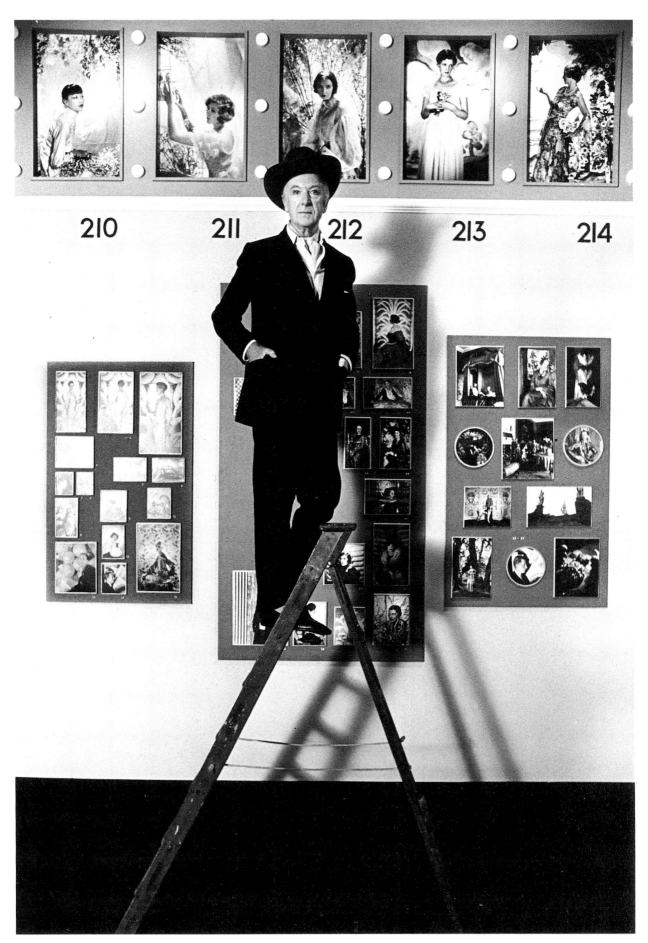

210 211 212 213 214

Cecil Beaton, National Portrait Gallery, London, 1968

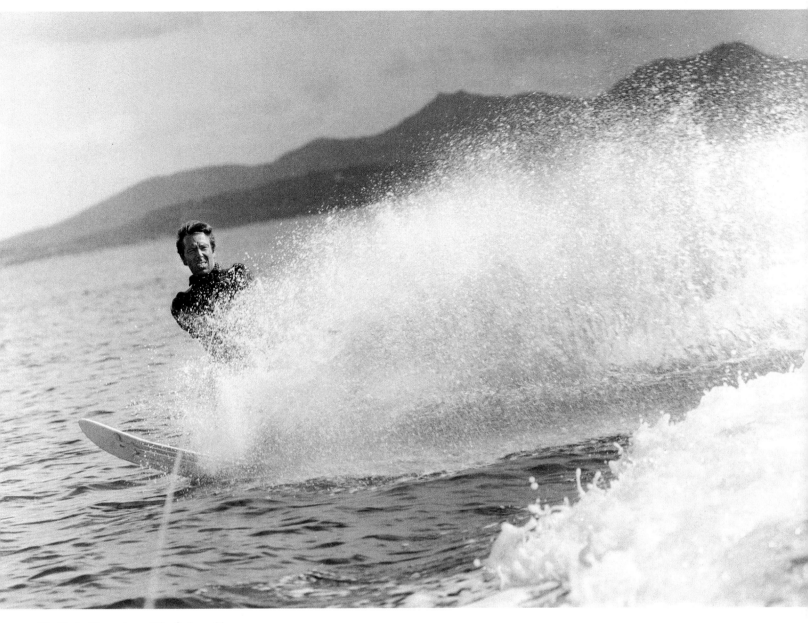

The Earl of Snowdon, off Sardinia, 1966

Cecil Beaton is posed in front of his own photographs at the National Portrait Gallery, preparing for the exhibition of them held there in 1968. It was the first ever exhibition of a leading photographer's portraits in Britain. Beaton, probably the first photographer to be widely known outside the profession he adorned, died in 1980.

By contrast, the picture of Lord Snowdon was taken during a moment of relaxation. He is no stranger to water sports, having coxed the Cambridge eight in the 1950s.

Like Beaton, Lord Snowdon is as well known outside his professional sphere as within, not least because his photographs are so technically and artistically convincing.

Horst P. Horst is a less famous photographer than Beaton and Snowdon outside his profession, but to those who know anything of the art he is one of the most respected practitioners in the world. This picture of him was taken in Nassau.

David Bailey, though every bit as distinctive a photographer-personality as Patrick Lichfield, became famous some years earlier, yet his face was hardly known to the general public until the appearance of television advertisements for Olympus cameras in the Eighties, in which they both participated. The picture of him here is from his own book of photographic mementoes of the Sixties, *Goodbye Baby & Amen*. It is the only picture in the book not by him.

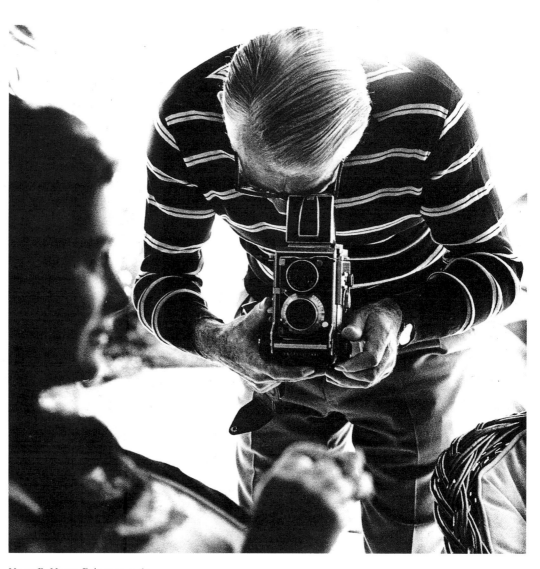

Horst P. Horst, Bahamas, 1967

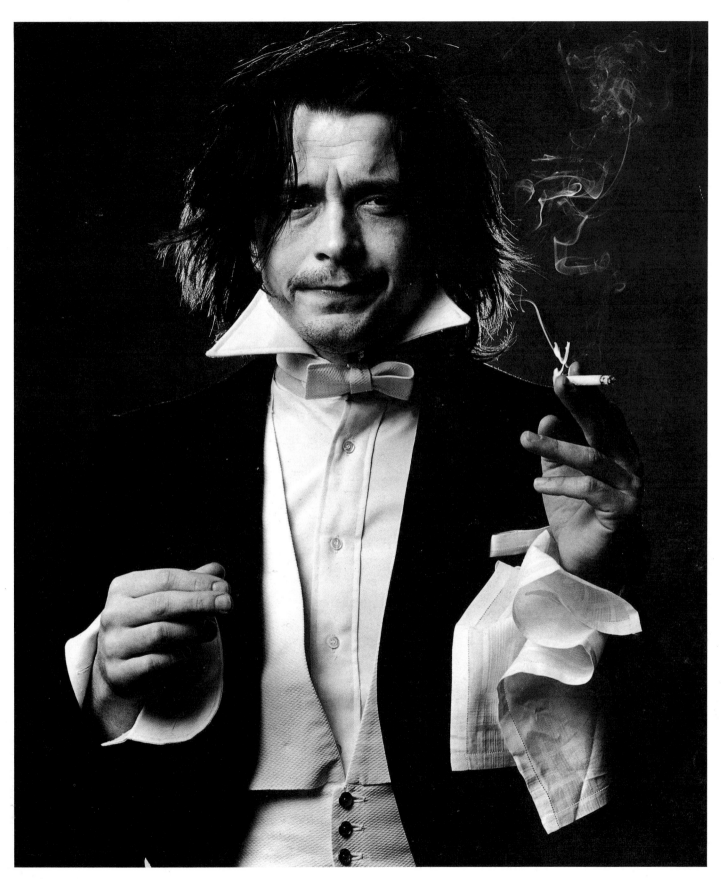

David Bailey, 1969

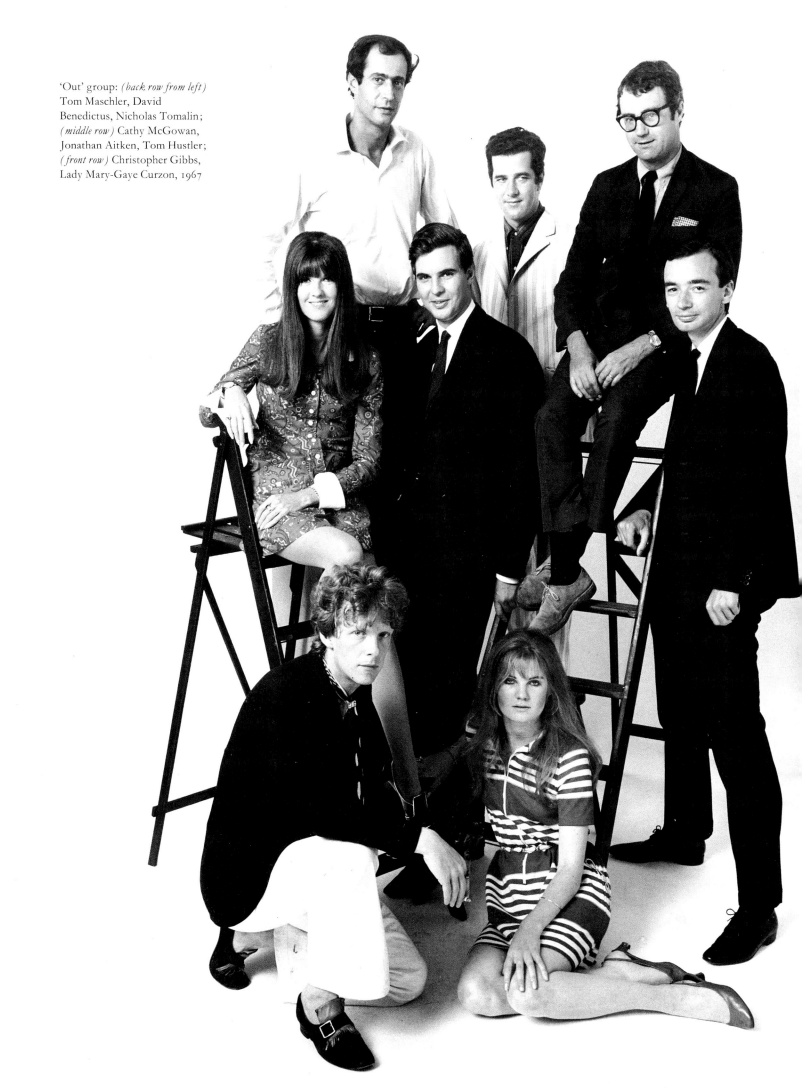

'Out' group: *(back row from left)*
Tom Maschler, David
Benedictus, Nicholas Tomalin;
(middle row) Cathy McGowan,
Jonathan Aitken, Tom Hustler;
(front row) Christopher Gibbs,
Lady Mary-Gaye Curzon, 1967

'In' group: *(clockwise from top)*
Peter Cook, Tom Courtenay,
Twiggy, Lucy Fleming,
Miranda Chiu, Michael Fish, Joe
Orton, Susannah York, 1967

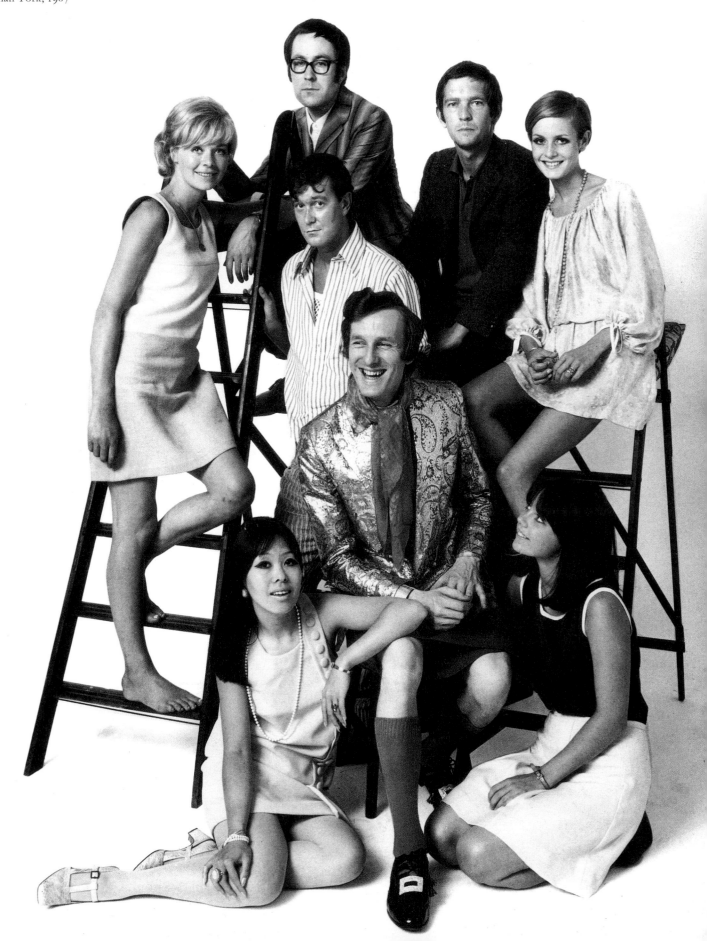

Trumbull Barton and John McHugh, 1969

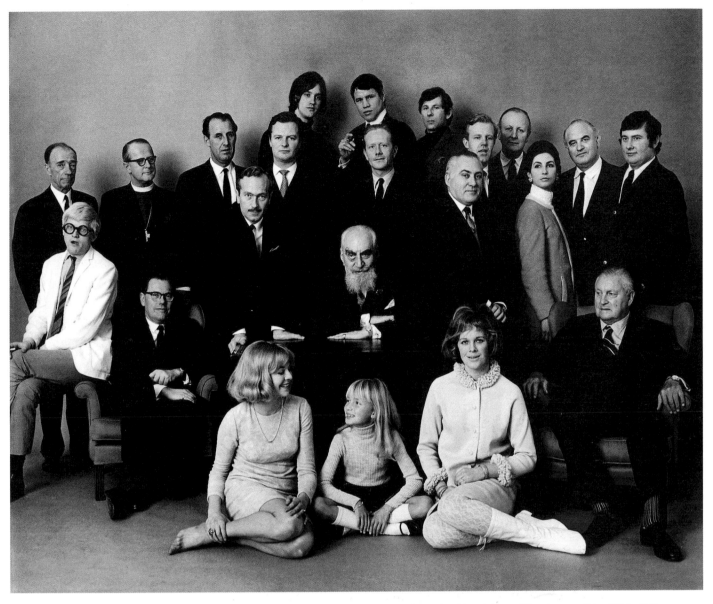

'Swinging London' group: *(from left to right, standing)* Prince Dimitri Romanoff, Ronald Goodchild – Bishop of Kensington, Dave Dick, Colin Chapman, David Hicks, Ray Davies, Terry Downes, the Marquess of Hertford, Roman Polanski, Jocelyn Stevens, Peter Wilson, Janet Lyle, George Weidenfeld, Terence Donovan; *(sitting)* David Hockney, Reginald Maudling, Susannah York, the Hon. Katharine Douglas, Newbar Gulbenkian, Milton Shulman, Lady Antonia Fraser, Lord Douglas of Kirtleside

Jocelyn Stevens's magazine *Queen* may not have been the first to draw up lists of who, what or where was 'In' and who, what or where 'Out', but it seems in retrospect to have done so more often than others. The habit was so prevalent that it even filtered down to the ephemeral magazines put out on high holidays by boys at Stevens's old school, Eton. The difference between the In group and the Out group, on pages 76 and 77, derives, it has been suggested, from little more than the favour or lack of it with which the people in question were viewed by Stevens himself.

The group on this page was less arbitrary in selection,

because it was commissioned by *Status*, an American magazine with more definite ideas about what it wanted its readers to see, even if it may have lacked the specialized knowledge that made Stevens's judgements so pungent.

Trumbull Barton and John McHugh were two anglophile American socialites living in a brownstone in New York, whom Patrick Lichfield got to know during his years in that city in the late Sixties. Their caustic commentary on British people and customs may have contributed to the 'acceptable' or 'unacceptable' status of the characters in view on these pages.

THE
1970s

Patrick Lichfield, 1978

Ryan O'Neal, 1971

To a great many participants the end of the Sixties came with a certain breathlessness. People had hardly started to get their bearings, as it were, before December 1969 loomed. Yet although the Sixties might have ceased on the thirty-first of that month, the momentum of social flux did not abate. The Seventies was to continue that momentum for a few more years yet. Indeed, even when catastrophe struck in 1973, it had nothing to do with the head of steam built up in fashion, society or the arts during the late Sixties and early Seventies. Like the iceberg that sank the *Titanic* in 1912, it was an exterior phenomenon. The early Seventies foundered on the iceberg of economic crisis caused by the 1973 Middle East war and the quadruple rise in the price of oil.

The breathlessness had been perfectly understandable given that so

much had happened between 1960 and 1970. The Seventies, however, saw not just a further spell of experimentation but a widening of the social circles that went in for experimentation. Because of this there was a retardation of the rate at which one experiment was discarded and the next taken up. Changes in personal appearance offer a good example. In the Sixties the geometric Piet Mondrian look in clothes, then the Op Art look, were succeeded within a year or two by vaguely nineteenth-century costumes and hairstyles, which in turn succumbed rapidly to the whole range of psychedelic visual idioms, Oriental mysticism, simple colour schemes and a gentleness of demeanour bordering on quietism embodied in 'flower power'. The Seventies culminated in Punk, a style that is very much extant ten years later.

If Sixties fashions in clothes had reflected ways of looking at the world – Mondrian or Op Art as the visual awareness of art school graduates released from the confines of formal education and feeling their way in the great wide world, the Victorian look as a slightly sardonic exercise in nostalgia, flower power as a yearning after the spiritual – so too did the Seventies. The Punk phenomenon – and its longevity, which itself is nothing if not phenomenal – has been diagnosed as an expression of the nihilism and frustration affecting youth at a time of increasing unemployment. The decline of formal religious observance in Britain and an impatience with traditional culture probably contributed to this picturesque form of protest.

In the Sixties the contrast between last week's style and this week's had made it seem as if society itself was trying on a series of clothes before deciding what was most congenial. Of course what was most congenial was not necessarily what suited society best in the opinions of observers, but that is the way with clothes. From the end of the Seventies onwards a curious rigidity seized the disenchanted young from whom adherents of Punk were drawn. This group – a substantial segment of society – clung to a particularly bizarre fashion with unprecedented tenacity. It was almost as if a child had pulled a face, the wind had changed and the child was stuck with the grimace, just as nanny had warned.

Punk was the most violent assault on conventional sensibilities yet, although it was perhaps remarkable that society retained any reserves of outrage at all after its buffeting in the Sixties. After three or four years Punk even became accepted and imitated by people beyond the circle of nihilistic young who had launched it, including fashion and interior designers, theatre and film producers, and parents clinging to their youth. It was very much a British phenomenon, though it was eventually taken up abroad. It even became something to be proud of; it proved that Britain could still startle the world.

Today, however, whereas Sixties fashions tend to seem quaint, those of the Seventies arouse something more like horror. This is not entirely due to the fact that they are much closer in time to the present; nostalgia for the Sixties had been immediate, so why could it not be immediate for the Seventies too? 'Good Heavens, did I really wear/look like that?' is the commonest reaction on the part of survivors when confronted with evidence of their sartorial turpitude in the Seventies.

Society is an ambiguous term. It can mean fashionable circles, in the

way a young man is described as 'having to make his way in society' or a woman is called a 'society hostess'. It can also mean the whole mass of human beings constituting a nation state and its shared culture, as when society is described as having 'set its face against the return of capital punishment'. The point is that whereas at the beginning of the Sixties it was still plausible to talk of society in the first sense, that of the 'Upper Ten Thousand' or, to borrow a number from American life, 'The Four Hundred First Families' (the restricted circle centred on New York in the late nineteenth and early twentieth centuries), by the Seventies no such homogeneous entity existed any more. The huge variety of modern life was a cause of the fragmentation, for a concept such as the Upper Ten Thousand, if it is to mean anything more than a mere number, predicates a group of humans with a broad set of characteristics in common – a shared outlook, or at any rate collective assumptions, and above all a restricted geographical area in which they operate, hence one that was inevitably burst asunder by the spread of the automobile.

By the Seventies it was really only a fair description of circumstances to use the term in the second sense. But even society in this sense had become too diverse for unanimity to be ascribed to it. In Britain it wasn't only the generation divide, though that had become more acute since young people had started to have their own money. Nor was it entirely increased travel by Britons, immigration into Britain from outside (particularly a non-European outside) and generally improved communications with the world at large. It wasn't a divide between town and country, as it had largely been before the twentieth century, or between north and south, as was to be claimed in the Eighties. It was principally the divide between those who had done well out of the English social revolution – that enormous Sixties shift in the allocation of prestige – and those who had not. The unfortunates were sometimes people who had managed to clamber aboard the bandwagon for a few laps but who had then fallen off – members of a once famous pop group now sunk back into obscurity, for instance. Or they might be people who felt they had never got a chance to climb aboard the bandwagon at all. The industrial unrest of Britain in the Seventies surely owes something to the latter phenomenon. This is not to say that the majority of the population has not usually been contented with life. Certainly opinion poll after opinion poll has shown this to be true of the British. But there have always been some who look beyond what they see as a humdrum existence and who desire to participate in the prestige, publicity and wealth accruing to the successful. In most cases they have had to be content with dreams rather than reality. But in the Seventies, with so many practitioners of hitherto unremarkable callings such as hairdressers, photographers, clothes designers, boutique owners and restaurateurs having made good in the Sixties, it became apparent to ordinary people that social as well as financial success was more than a pipe dream even if one was not in a traditionally revered occupation such as that of scholar, statesman or cultural figure.

Inevitably, since not everyone could make good, there was disappointment. Part of the Sixties revolution had involved Britain's becoming more like America, where more grandiose ambitions had always been common. But grandiose ambitions unrealized bring disproportionately

corrosive discontent. Hence in part the waves of strikes, huge wage demands and even anarchist activities in Seventies Britain.

In the old days the rich, the famous, the well-born had been so remote from most people's lives that their activities had seemed fabulous in the literal sense – like a fairy story or fable – especially given the way the activities had been chronicled by the popular press. The Sixties had been revolutionary partly because it had shown that the fairy-tale court was penetrable by ordinary boys and girls – ordinary boys and girls, moreoever, who kept their homely ways, who did not simply ape the manners of their new companions. When Twiggy was invited to stay with the Duke of Bedford at Woburn Abbey there was no Eliza Doolittle nonsense about her having to learn a new set of mannerisms. She was invited for what she was and she went as what she was. All this made people realize that they too might participate, even if they hadn't managed to do so yet. In previous generations the professional success in certain lines of business had had to be a social success as well. Noël Coward, for instance, had adopted a personality that was almost a caricature of the languid aristocrat. When Lesley Hornby from Neasden could become Twiggy without having to sacrifice her north-west London vowels and Reg Dwight from Pinner could become Elton John without having to jettison his barrow-boy outrageousness – because of it rather than in spite of it, in fact – their fellows began to think, 'Why not me?' More than that, they increasingly began to act on the possibility.

High society, which in practice tended to mean something more like the restricted group of urban sophisticates known as café society, had been remarkably accommodating to the handful of pop stars and other new arrivals who had done well in the Sixties. The operative word was very much 'handful', however. The group of mostly young men and women (plus a few honorary youths such as Cecil Beaton) on whom public attention had battened in the Sixties was extraordinarily small. Estimates of their exact numbers vary, but a couple of hundred is a figure frequently cited. Two hundred happened to be roughly the number of people a new discothèque could expect to accommodate at its opening night party. In short, the term 'magic circle', which had been so damagingly flung at the Conservative Party in Britain in 1963 by the politician and journalist Iain Macleod in referring to the mysterious clique that had chosen Lord Home to succeed Macmillan, applied just as much to those very un-Conservative people who were in 1970 seen as having epitomized the Swinging Sixties. Now, more and more outsiders were determined to join this intoxicating, colourful non-stop party that was the English social revolution.

Many Sixties tendencies were taken to extremes in this decade, sometimes acquiring in the process a slightly grotesque quality of exaggeration, rather as the dentition of a sabretooth tiger appears overdone. Men's hair got even longer, the care necessary for it certainly more elaborate; ties became wider till they were compared with kippers and lapels on jackets broadened likewise; trouser legs flared till they outdid the Oxford Bags of the Twenties. Even the new prime minister, Mr Edward Heath, grew his hair to a condition of shagginess quite startling in a statesman.

For the first few years the era of easy money continued too. Much of

the exuberance of the Sixties had arisen because for the first time ever the masses had had a bit of spare cash to spend and some bright toys, if rather gimcrack ones, to spend it on. In the early Seventies financiers such as the British takeover king Jim Slater soared to ever more cerulean heights, the price of property almost doubled in twenty-six months (1971–4), more and more old buildings were ripped apart to be replaced by new ones. The term 'asset-stripper' entered the English language. This was a menacing-sounding name for those who sold off the previously undervalued parts of a company for more than the price they had paid for the whole. One might as well have called the previous owners 'asset-neglectors', and it is doubtful if selling off previously undervalued assets would have seemed so opprobrious to Americans. Although there were plenty of solid, lasting successes, the disasters made better newspaper copy so that the Seventies gave as vivid an impression of financial volatility as the Sixties had of sartorial volatility. It is true, however, that Jim Slater's empire eventually came apart at the seams. So did Bernie Cornfeld's ios (Investors Overseas Services). Some of those with the highest responsibilities in the land – the United States as well as Britain – were destroyed by financial irregularities, either directly or through unfortunate contacts with those who were genuinely guilty. Spiro Agnew resigned as vice-president of the United States in 1973, Reginald Maudling as home secretary in Britain the previous year.

The weekend supplements which had started up in Britain in the Sixties did much to increase their parent newspapers' circulations in the Seventies. They performed the function of etiquette books in earlier times, instructing the newly prosperous in approved ways of laying out their wealth, teaching them what to cook and how to serve it, what restaurants to visit, what to wear, how to furnish their houses and where to go on holiday. As formal education succumbed more and more to theories exalting creativity over acquisition of knowledge and spontaneity over discipline, above all in comprehensive schools which mixed children of very different abilities, the colour supplements even took on the task of instructing readers in what writers and painters to admire, or what historical parts of the country to explore. They were particularly effective in purveying history when acting in concert with a well-organized museum exhibition. The Tutankhamun exhibition of 1972 was the most famous of these. The supplements' lavish use of colour photographs made them ideal for their task in this respect, and even if they tended towards oversimplification, it was no more than any schoolmaster or schoolmistress was likely to go in for, given lack of time and larger, more mixed classes.

A few – a very few – had shed an immediate tear for the departing Sixties. It is perhaps the swiftest instance of nostalgia on record. David Bailey, whose timing and sure touch in fashion were then uncanny, had brought out his book *Goodbye Baby & Amen* in late 1969 as a kind of instant threnody for the decade then drawing to a close. Some of the people in *Goodbye Baby* have remained famous, others would now mean nothing even to a relative specialist in the decade. The lettering listing the photographer's subjects was relentlessly lower case, the photos themselves black and white, the predominance of black giving a distinct flavour to the book as an elegy for the dear departed. Some photos were grainy and 'artistic', others stark

portraiture. The overall impression makes the Sixties seem very distant from the Eighties.

But for most people the party had just begun. Inevitably, as the gatecrashers multiplied, the party underwent a certain coarsening. For one thing it sometimes grew genuinely hard to keep up the gaiety of the Sixties – and not just because 'gay' was now coming to mean homosexual. The Beatles broke up in 1970, the new Biba fashion store opened in larger premises in 1973 but had to close less than two years later. The sapping of conventions brought problems. Drugs became harder, publicity more relentless, the notion that fame and riches necessarily brought happiness more difficult to sustain. Terrorists were mercifully rare on the British mainland and in North America, but in the latter kidnapping became more than a theme from dime novels: a Bronfman, a Getty, a Hearst all fell victim to this crime. In Britain it was a decade of unnatural death: in 1974 Lord Lucan disappeared, leaving a dead nanny behind him; in 1975 Dominick Elwes, a portrait painter and member of the 'Lucan Set' who allegedly had feared he was suspected of indiscretion by its other members, killed himself; so the same year did Caspar Fleming, Ian Fleming's son; in 1977 Sir Eric Miller, a financier friend of Harold Wilson's, shot himself.

It is harder to say with certainty how or to what extent the radicalism and the irreverence of the Sixties were modified in the following decade. The satire boom had finished as far as television was concerned by the mid Sixties, though the major growth of *Private Eye* and the *succès de scandale* of *Oz*, a radical magazine edited by an Australian, Richard Neville, and two other young men, occurred subsequent to the Sixties. The *Oz* 'Schoolkids' issue, a number of the magazine that was alleged to be corrupting, particularly of youth, was tried for obscenity in 1971. A much more potent combination of sexual and civic preoccupations was embodied in the rise of feminism, called in those days 'Women's Lib'. Germaine Greer, another Australian, was its high priestess in Britain.

The Seventies was a decade of shocks. The Conservative Party's victory in the British general election of 1970 was the first. Hardly anyone had expected Mr Wilson to fall from power. In retrospect the Conservative victory was indeed no great upset in terms of the last six years, but that was not apparent in 1970, when the shock was felt. Actually Mr Heath's administration made so many changes of policy that the expression 'U-turn' was attached to it with remarkable aptness. But leading politicians of all parties began to pay great attention to fashion, far more than they had in the Sixties. Lords Jellicoe and Lambton went in for permissiveness, but had to resign from the government in 1973 when both were discovered to have consorted with a call girl. Jeremy Thorpe, the leader of the Liberal Party, went in for sharp 'gear' – that evocative Sixties and Seventies word for clothing – but he too was overtaken by events in 1976. Anthony Crosland, the Labour Party's leading ideologue, rebelled against formal evening dress at official state functions. John Stonehouse, a one-time Labour minister, allowed fantasy to carry him out of politics altogether when he faked his own suicide in Florida in 1974 and tried to start a new life in Australia.

In America the disarray among politicians started at the very top, with President Nixon's discomfiture over Watergate (1972–4). His

misdemeanours were themselves very much of the times. Electronic eavesdropping was the sort of thing James Bond might have gone in for.

All this was heady stuff compared with the entertaining but relatively lightweight questions of Sixties politics: how to choose a leader of the Conservative Party; was there an anti-Wilson plot inside the Labour government? In Britain in the winter of 1973–4, what with the coal strike, the three-day week, inflation and terrorist bombings, a lot of usually sensible people began to talk of society collapsing. A revolutionary, or at least a pre-revolutionary situation was said by some to exist. There were even reports of private armies being formed. A retired soldier, Sir Walter Walker, was cast in the role of generalissimo by feverish commentators. In comparison the Sixties had merely played with political fervour, the genuinely insurrectionist character of that decade being confined to the social sphere.

In the United States a similar air of confusion permeated the atmosphere. Nixon had been elected in part because he was pledged to get the country out of Vietnam, and his general reputation for toughness – even unpleasantness – made him seem like a promising negotiator with an adversary who was also recognized as unpleasant: the Vietnamese communists. After Nixon's early retirement there came the amiable pratfalls of Mr Ford and then the *Mr Deeds Goes to Town* (1936) innocence of that ultimate provincial-in-Washington, Mr Carter. Within seven or eight years both the reputation of the United States abroad and the character of the government itself had changed completely. Americans, so dependent on the motor car and so hostile traditionally to government interference, acquiesced tamely when drivers were subjected to one of the most restrictive speed limits in the world. The Seventies was truly a time of fluctuation, with political seesawing especially pronounced.

As far as intercourse between America and Britain was concerned, the Seventies saw increasing numbers of television programmes exchanged. Ten years after the British satirical television shows *That Was The Week, That Was* and *Not So Much a Programme...*, both of which were essentially cabaret brought into people's households by the cathode ray tube, the British were treated to an American version of the same thing in *Rowan and Martin's Laugh-In*, though this was much more reliant on visual gags than the British prototypes had been. Meanwhile the export to America from Britain of colourful but sometimes misleading portraits of Britain continued: *The First Churchills*; *Upstairs, Downstairs*; *The Pallisers*. They misled, if they did mislead, less because they misrepresented Britain's past than because they confirmed American suspicions about its present.

Transatlantic travel remained cheap – much cheaper on a penny per mile basis than to destinations in Europe, despite Britain's having joined the Common Market in 1973. Once Britain was a member, flights to Paris or Rome from London should have been brought down in price. They were not.

Just as the frivolous Twenties were followed by the sombre Thirties, so the easy-going Sixties shaded into the brutal Seventies. To talk of the new decade's development in terms simply of dress, hairstyles, who was fashionable and who not and other visual or social aspects is therefore much more mistaken than in the Sixties. The Seventies growth industry was

arguably violence, and the organized variety at that. Violence of that sort is properly for politicians to deal with: it is their task to ameliorate the conditions giving rise to violence, just as it is the policeman's task to give immediate relief by catching the criminals. Accordingly politics looms larger in the Seventies than immediately before.

The picture of the Seventies as an era of cultural consolidation is true as far as it goes but, if drawn without reference to the political developments, risks overlooking a good deal. In the Sixties style had been a major preoccupation, legitimately so perhaps. In the Seventies changes of substance took place. Although style could and did adorn those changes it was now much more a superstructure, almost an excrescence.

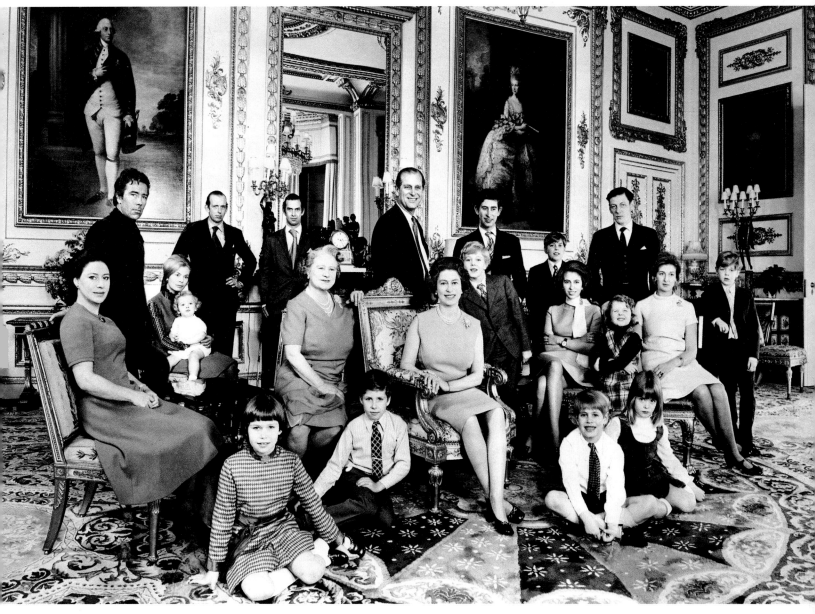

The royal family, Windsor Castle, Christmas 1971

Patrick Lichfield's multiple portrait of the royal family at Windsor Castle has become one of the twentieth century's most celebrated pictures of royalty. It was even paid the compliment – a somewhat backhanded one, admittedly – of being caricatured by the late Nicolas Bentley in a cartoon in *Private Eye*. Patrick Lichfield has told the story in his autobiography of how difficult it was to shoot. Before the First World War photographs of royalty *en masse* were taken under highly formal conditions, which made things relatively easy since they allowed no great departure from convention. Each sovereign or relative of the sovereign was grouped according to considerations of hierarchical position as well as physical size, each male

trussed up immobile in braid, aiguillettes, high collars, epaulettes and high boots, each female in the rigid underclothes and voluminous outer clothes of the day. It was like photographing a regimental group. By 1972 the problem was assembling a group of around a score, several of whom were children, in an informal and cheerful way without its seeming either posed or anarchic. Although royalty are more disciplined than most people it must still have been a strain. In the end, the only way the necessary composition could be achieved was to paste separate pictures together in a massive collage. Thanks are partly due to the Marx Brothers on television for keeping the sitters amused while the shots were taken.

The Queen on board *Britannia*, 1972

The picture of the Queen laughing uninhibitedly was taken on board *Britannia* when crossing the equator. Patrick Lichfield, who had been invited to take photographs of the Queen on a foreign tour, was crossing the line by sea for the first time and was accordingly ducked, camera in hand. The Queen found this amusing.

The Balmoral pictures were taken while Patrick Lichfield was staying with his cousin to take photographs for the Queen's and Duke of Edinburgh's silver wedding anniversary in 1972. The twin portrait session went so well that only one roll of film was taken and the picture was used in Australia on the Silver Jubilee Post Office stamp in 1977.

The photograph of Prince Charles in a kilt about to be embraced by Lady Sarah Armstrong-Jones has become almost as famous as the 1971 group portrait. In captions for some publications the subjects were described as dancing, but in reality Lady Sarah, back from a trip abroad, had arrived late at an out-of-doors excursion and simply rushed to greet the prince. Patrick Lichfield put his camera, which is always loaded, on automatic drive to capture her running towards her cousin.

Prince Charles and Lady Sarah Armstrong-Jones, Balmoral, 1972

The Queen and Prince Philip, Balmoral, Aberdeen-shire, 1972

The Queen, Balmoral, 1972

As the Seventies arrived some of the most characteristic personalities of the previous decade began to bow out. One such was Jean Shrimpton; she and Twiggy had been the most famous models of the Sixties. She retired in the early Seventies and rusticated herself in the West Country.

There are fashionable places as well as fashionable people, although in Britain there has not been the intense preoccupation with 'OK places to eat' that so bedevils dining out in New York. San Lorenzo has been an exception. It is situated in Beauchamp Place, a narrow little street off the Brompton Road not far from Harrods.

Jean Shrimpton, Shugborough, 1970

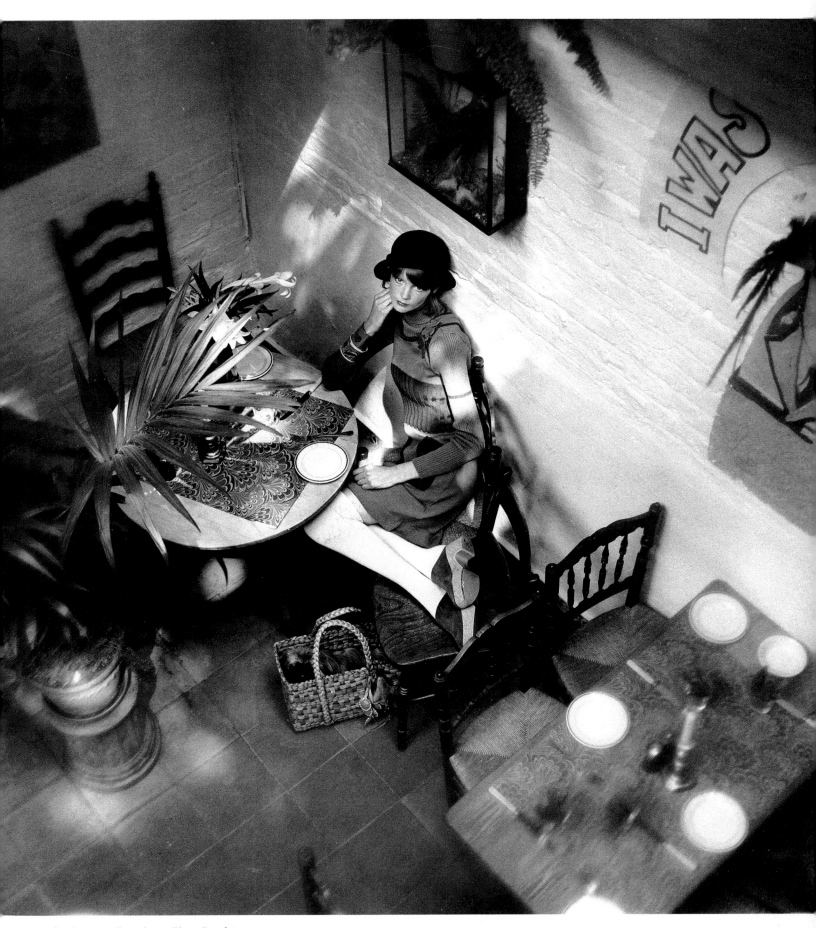

San Lorenzo, Beauchamp Place, London, 1971

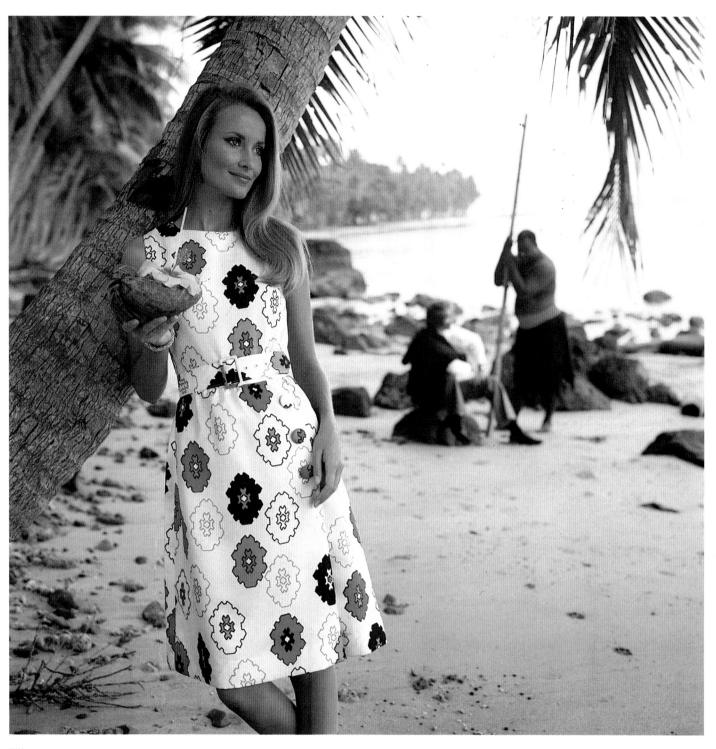

Fiji, 1972

Tobago, 1970

Joanna Lumley is well known for a single role, that of Purdey in *The New Avengers* (1976), as *The Avengers* was renamed on being revived. Her television name was apt, given the pretensions of her foil John Steed (played as always by Patrick MacNee) to being a gentleman – Purdey is the name of one of the great sporting gunsmiths. Joanna Lumley had an august tradition to live up to: (going backwards in time) Linda Thorson, Diana Rigg, Honor Blackman. Like Doctor Who, the female Avenger would change every so often, conferring instant recognizability for years after on the actress chosen.

Joanna Lumley is not just an actress, however. She has written columns for *The Times* and edited an anthology of *Spectator* literary competition-winning entries. At the time this photograph was taken she had recently appeared in *Some Girls Do* (1969), a Bulldog Drummond spoof.

Joanna Lumley, Regent's Park, London, 1971

Karen Pini, Provence, 1979

A purist might have complained that the cult of personality among models from the Sixties onwards obscured the qualities of the product being modelled. It was fashionable to call the process 'the medium overtaking the message'. This, by contrast, seems to be a pure fashion shot, drained of all irrelevant and distracting human content. In fact there is a human interest story behind it: the manufacturers of the tights had been known for their gloves in the past, hence the leather thumb. Human interest is the essential element of successful advertising. Even shop window dummies are modelled on real-life individuals; some shops in fact used 'Patrick Lichfield' models at one time.

A good example of the superior appeal of content over packaging is the picture of Karen Pini. She was runner-up in the Miss World contest in 1977, which must be an infuriating disappointment, like being the second man on the moon, or the second human being on earth. She even resembles the latter.

Fashion shot, 1972

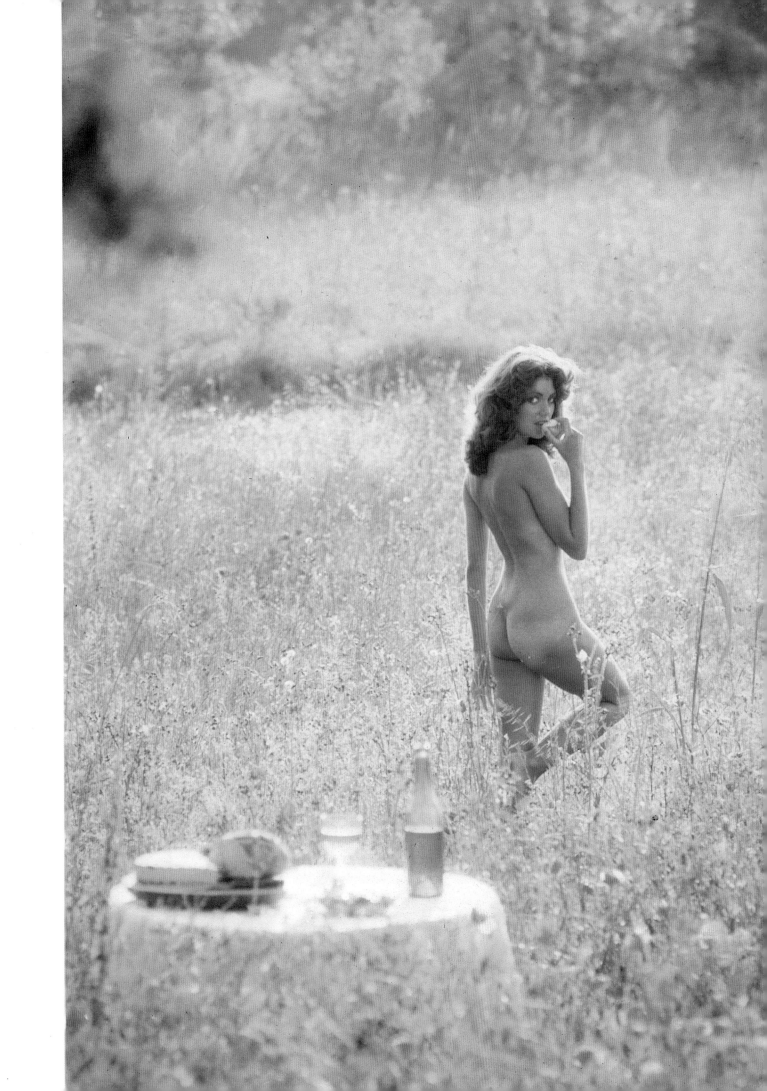

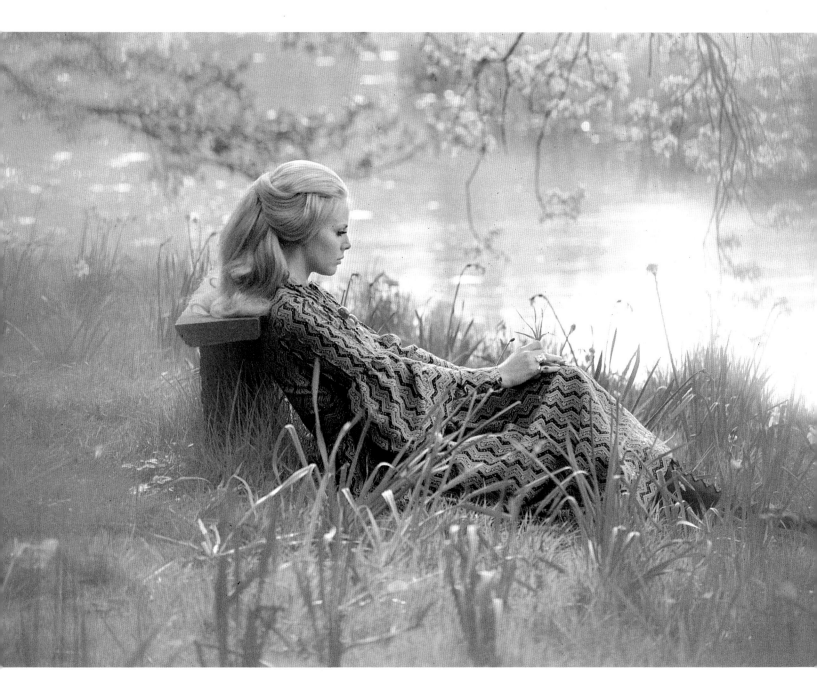

Britt Ekland, Shugborough, 1970

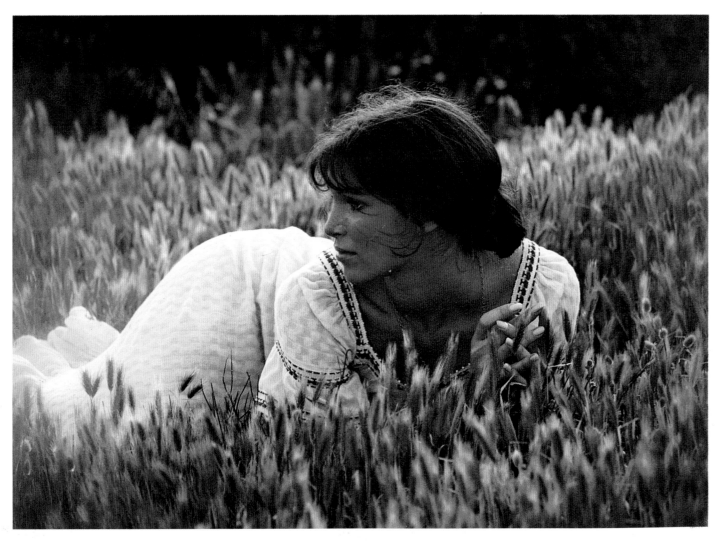

Ann Turkel, Sardinia, 1971

Britt Ekland, in contrast to Karen Pini, gives the impression of being a little too well buttoned up. The tendency to coolness of an English spring makes this understandable. The surrounding leafy bloom and slowly running stream behind suggest just that combination of lushness with a chilly undercurrent that is England in April.

Britt Ekland's major film roles have belied the impression of vernal innocence conveyed here: *The Night They Raided Minsky's* (1968); *Get Carter* (1971), a thriller; *The Man with the Golden Gun* (1974), another thriller (based loosely and tediously on a late text in the James Bond cycle); *The Wicker Man* (1973), an underrated film about a sinister folk ceremony in remote Scotland; and *Royal Flash* (1975), a film of one of George Macdonald Fraser's romps involving Flashman.

Ann Turkel's pose conveys a curiously feral impression, despite the formality of her dress, the studious interlacing of fingers and the gentleness, politeness almost, of the physiognomy. She married the actor Richard Harris and had parts in two films in which he starred – *The Cassandra Crossing* (1976), a disaster movie, and *Golden Rendezvous* (1977), a thriller. Patrick Lichfield has often said she is the most beautiful girl he has ever photographed.

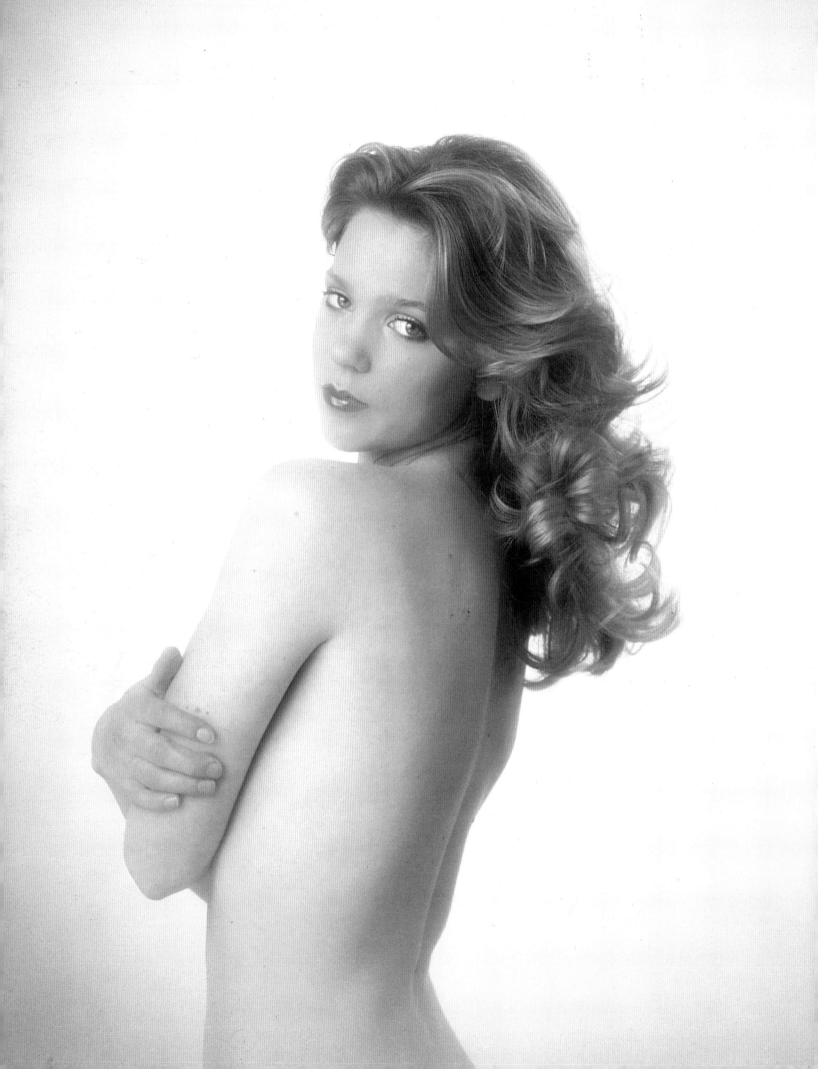

Stephanie Grainger, 1974

Lady Liza Campbell is the second daughter of the Sixth
Earl Cawdor, who is also, more poetically, the Twenty-
fourth Thane of Cawdor. She thought she might like to try
her hand at modelling at one time, so Patrick Lichfield
took a series of test shots.

 Stephanie Grainger also did some test shots with a
view to modelling, a career she pursued with some success.

Lady Liza Campbell, 1978

Tracy Reed, Knightsbridge salon, London, 1971

Diana Rigg, 1977

Tracy Reed, step-daughter of the film director Sir Carol Reed, had a small part in *Dr Strangelove* (1963). She is here posing for a fashion feature on the sauna facilities of a Knightsbridge shop.

Although Diana Rigg will always be remembered for her part as Emma Peel in *The Avengers* (which was launched with Honor Blackman in the part in 1961), her career later took a more classical turn. She appeared in a number of televised Shakespeare plays and in a television adaptation of Dickens's *Bleak House* (Dickens, like Shakespeare, being a superb writer for television *avant la lettre*). The photograph of her here is from a series designed to display her versatility which also included her portrayal of a prostitute and a dowdy housewife.

Maggie Smith is admired as much for her theatrical work as for her roles in films, but her progress in the cinema was far more rapid, beginning with a scrap of a role as a secretary in *The VIPs* (1963) (in which she stole a scene from the stars Richard Burton and Elizabeth Taylor). At the time the photograph here was taken she was fresh from her triumph as Jean Brodie in *The Prime of Miss Jean Brodie* (1969), for which she won an Oscar. She won another for best supporting actress in *California Suite* (1978).

The shot of George Melly was for a *Cosmopolitan* feature on middle-aged men. He is versatile, being a jazz singer and writer as well as knowledgeable about Surrealist painting. It must have been his turf accountant check suits and Roaring Twenties gangster haberdashery that led the city of Birmingham to use him in an advertising campaign to enliven its reputation – presumably based on the subconscious identification he might lead viewers to make between Britain's second city and the USA's (Chicago). For many years Melly wrote the *Flook* cartoon strip in the *Daily Mail*. (When Harold Macmillan was prime minister he used to say he never read the press except *Flook*.) Throughout most of the Sixties Melly was also television critic of the *Observer*.

Maggie Smith, 1970

George Melly, 1973

'Rock culture', 1976

'Rock culture' was commissioned by the Springer Press of
West Germany to show its readers how Britain was
progressing after the Swinging Sixties. The girl with the
heavy eye shadow and bulky black dress in the middle of
the back row provides one of the first glimpses of Punk.

Ron Wood was taken on as the Rolling Stones' lead
guitarist in the Seventies and is pictured here in an album
cover shot for Warner Brothers' record division.

Ron Wood, 1974

At the time the picture of Dirk Bogarde was taken on the set of *Death in Venice* (released in 1971), he had been part of British cinematic tradition for at least a couple of decades. In his Fifties films, notably the 'Doctor' series based on the books by Richard Gordon, he had performed perfectly satisfactorily, but he always gave the impression he was capable of something more. Then in the Sixties he played the dominant role – dramatically speaking – in one of the decade's most atmospheric films, Joseph Losey's *The Servant* (1963).

Björn Andersen and Dirk Bogarde on the set of *Death in Venice*, 1970

Mick and Bianca Jagger, St Tropez, 1971

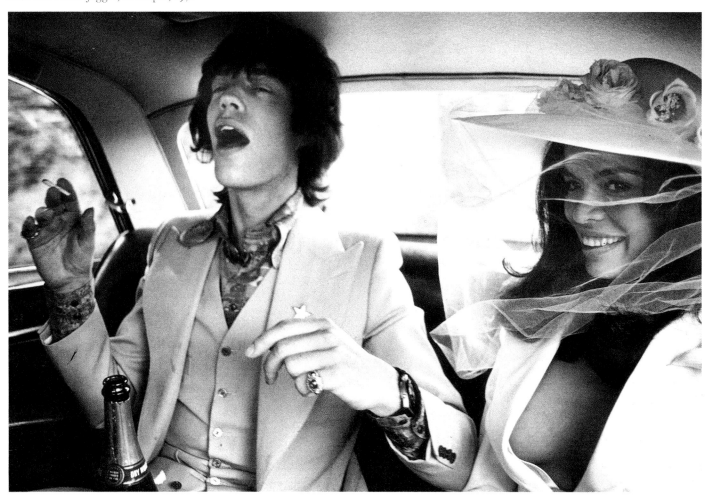

Jeremy Clyde and Paul Jones, 1970

Doug Hayward and Michael Caine, 1971

Another long-lived resident in the entertainment world is Mick Jagger, which is all the more of a feat in his case since pop music is so transient compared with films. His great achievement is to have made his life a work of public entertainment, as Oscar Wilde and Lord Byron did. He has been the undisputed despot of the pop world for twenty years. At Mick Jagger's wedding in St Tropez to Bianca Pérez Morena de Márcias from Nicaragua, Patrick Lichfield was asked to give away the bride. The photograph here was taken in the going-away car, a white Bentley, Patrick Lichfield being in the front seat.

One of the few successful ex-public school pop singers in Britain has been Jeremy Clyde, an Old Etonian and a grandson of the Seventh Duke of Wellington. In the Sixties he teamed up with Chad Stuart to become 'Chad and Jeremy'. By the time this picture was taken Clyde had turned back to acting; he is costumed here as a subaltern in nineteenth-century British India for the 1971 stage

version of *Conduct Unbecoming* by Barry England, a drama about a scandal among a small group of officers in a regimental mess in India. Paul Jones, the other young officer in this photograph, is much better known as a pop musician than Clyde, having been the lead singer in the group Manfred Mann.

Michael Caine has worn every bit as well in terms of career as Mick Jagger, possibly better, though he hasn't quite kept his figure in the same way. He has tended to play spies or military commanders with an irresistible combination of rough charm and plain common sense. He is one of the very few male sex symbols, perhaps the only one, resolutely to cling to spectacles. Astutely investing the money he has made from acting, he has been helped by the fashionable designer of men's clothes, Doug Hayward, who enrolled him with Patrick Lichfield as an investor in Burke's. The photograph of Hayward and Caine was taken for a magazine article on Cockney slang.

Nigel Dempster, 1977

Omar Sharif, 1973

Despite the way gossip columns have been an institution in newspapers since near the beginning of the twentieth century, few writers of them have enjoyed the kind of fame attaching to full-blown memoirists or diarists in previous centuries, men such as the Duc de Saint-Simon, Horace Walpole and Charles Greville. An exception has been Nigel Dempster in Britain – only Tom Driberg (later Lord Bradwell) and Patrick Kinross (at the time Lord Kinross) can compare, though some might put in a word for the Seventh Marquess of Donegall. All these writers were active in earlier decades, however, when social distinctions were more clear cut and the restraints imposed by good taste made investigation less searching. Life is no longer so simple but Dempster has coped with the demands of his profession with singular felicity, introducing a considerably more astringent touch.

Omar Sharif was one of the men in middle age featured by *Cosmopolitan* with George Melly. Latterly more active at the bridge table than under the arc lights, Omar

Sharif has played Westerners as easily as Arabs – acting, that is to say, not just in *Lawrence of Arabia* (1962) but *Doctor Zhivago* (1965) and *Mayerling* (1968), in the last two of which he played roles from high European culture.

David Niven, although a very British actor, actually started his career in Hollywood in the Thirties, but he was allowed by his studio to come back to Britain and serve in the Second World War. (He came from a military family and had gone to Sandhurst.) After returning to Britain he travelled assiduously back and forth to the United States, seeming to appear in as many British films as American ones. By the time this photograph was taken he had long made his name in Hollywood as an actor who could meet the American public's idea – it might equally be said ideal – of an English gentleman. Playing Count Dracula in a film called *Vampira* (1974), on the set of which this picture was taken, he still maintained a gentlemanly air. He too was one of the middle-aged men featured by *Cosmopolitan*, though sixty-four at the time.

David Niven, 1973

Jonathan Routh, at home in Piccadilly, London, 1973

Dean Martin, a member of the Hollywood 'Rat Pack', is famous for his role as the laid-back secret agent Matt Helm in the Sixties. Among his other films are *Rio Bravo* (1959), *Robin and the Seven Hoods* (1964) – a Rat Pack vehicle also starring Frank Sinatra and Sammy Davis Jr. – and *The Sons of Katie Elder* (1965). This picture was taken in his house in Beverly Hills, California which, although almost empty of furniture at the time, contained the equipment to make a good Martini.

Jonathan Routh is best known as the man who fronted *Candid Camera* in Britain. In this Sixties television programme, victims of practical jokes were filmed by a concealed camera. Routh is also a painter who was associated for some years with Olga Deterding, the Shell heiress. His eccentric nature led him to keep stuffed sheep as companions. Note the Mexican bandit moustache, grown by many men at the time.

Dean Martin, at home in Beverly Hills, 1974

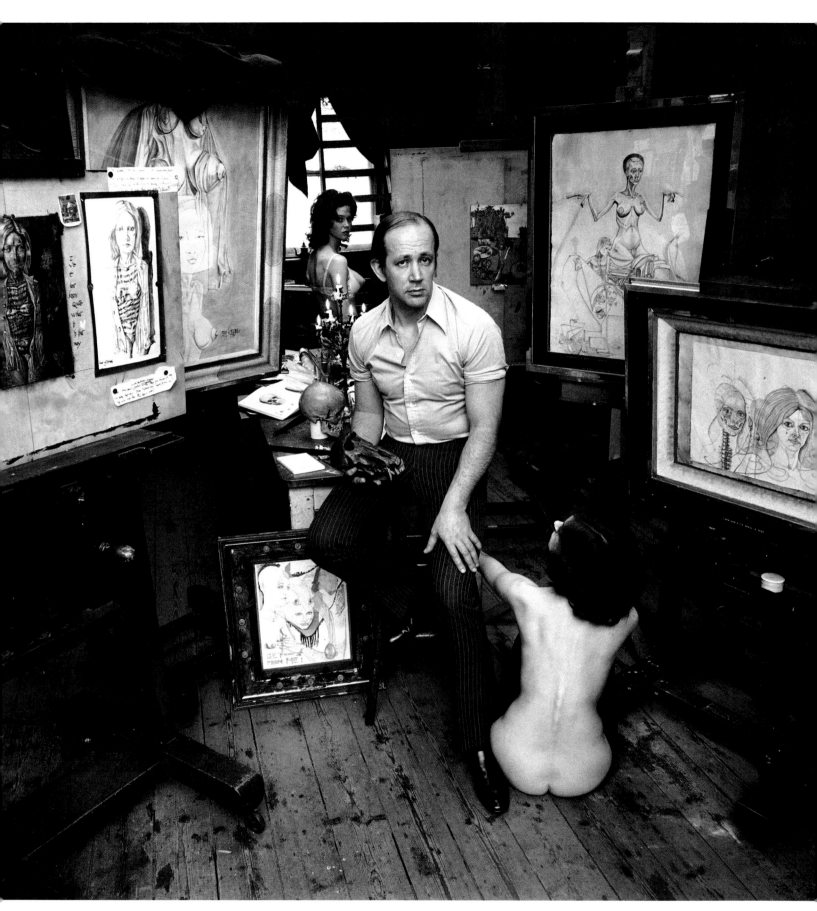

Louis de Wet, Notting Hill Gate studio, London, 1971

Tom Stoppard, 1976

The painter Louis de Wet – known for his macabre nudes – has a skull on the table by his right elbow as if to counterbalance the superabundance of flesh elsewhere in the room. The woman in the background is Gabrielle Drake, de Wet's wife and an actress who played in the long-running television serial *Crossroads* (which ran for around two decades until it was taken off the air in the spring of 1988).

Tom Stoppard made his name as a playwright with *Rosencrantz and Guildenstern are Dead* in 1967 and *The Real Inspector Hound* in 1968 but has turned increasingly to writing scripts for the cinema. He has most recently been involved in adapting J. G. Ballard's *Empire of the Sun* for the screen (1988).

Lord Clark, Saltwood, Kent, 1970

David Hicks, Jermyn Street office, London, 1979

Lord Clark became director of the National Gallery aged only 30; nevertheless he is best remembered as a superb communicator rather than an administrator or scholar. He performed a great public service by maintaining national cultural life during the Second World War. His biography of Leonardo da Vinci (1939) and his extended essay *The Nude* (1956) continue to be read but he is best known for his television series *Civilisation*, broadcast in 1969, in which he managed to popularize and make accessible man's cultural achievements.

The poised, brooding picture of David Hicks, behind him a De Chirico-inspired *trompe l'oeil* landscape, looks more like a bank manager refusing a loan than a well-known interior decorator. The photograph was advertising a watch, however. It is just discernible on Hicks's left wrist.

Lord Goodman, 1971

Both Lord Clark and David Hicks had links with the serious world where decisions are made – the one through such positions as his directorship of the National Gallery, the latter through his father-in-law, the proconsular figure of Lord Mountbatten. But it has proved important to have someone who can move with complete ease between the social world and that of the statesmen. Lord Goodman, Companion of Honour, sometime chairman of the Arts Council, senior partner in the solicitors' firm of Goodman, Derrick & Co, peer and master of University College, Oxford, has been of inestimable value in shuttling between the drawing room and the council chamber, like a domestic Henry Kissinger, and tidying up messes or soothing over misunderstandings. A trusted confidant of Edward Heath, Harold Wilson and Jeremy Thorpe, he has also in his time enjoyed the friendship of Lady Diana Cooper. Nor has he been close only to the older generation. When the bright young thing Nicky Waymouth got married to the jewellery designer Ken Lane in 1975, Lord Goodman gave the bride away.

A less rarefied man of business is Peter Marsh, chairman of the advertising agency ABM (Allen, Brady, Marsh). Hull, where this photograph was taken, is Marsh's home town. The photographer and his sitter had hoped to find the very street the latter had been born in but it had been demolished, so they tried to find one like it.

Lester Piggott, 1973

Barry and Stephanie Sheene, 1976

OVERLEAF: Liphook, Hampshire, 1973

Although brought up largely in the country, Patrick Lichfield has spent most of his adult life either in an urban setting or in exotic places abroad. It was not until his thirties and forties that he developed a passion for the English countryside. One aspect of this passion is trees, and he has built up considerable knowledge of them over the years despite the fact, as he points out, that very few species are truly native to Britain.

This love of trees was fostered by Lord Cawdor, one of his trustees. Lord Cawdor, the Thane of Cawdor, unlike his namesake in *Macbeth* feels so little threatened by woods as to have planted extensively on his estate. Patrick Lichfield has followed suit, installing an arboretum at Shugborough that contains seventy different types of oak. He hopes one day to be able to sit in their shade with a good book, though given the oak's slow rate of growth it will probably not be until, say, the Fifteenth Earl of Lichfield comes of age that they can be enjoyed in their maturity.

The red-twigged lime in this picture is one of the smaller trees on the Shugborough estate. Patrick Lichfield was leaving in something of a hurry one foggy day when its colouring caught his eye. He stopped the car and stepped out to photograph it.

He has carried out a number of photographic experiments involving trees at Shugborough, including one in which he left a camera trained out of a window in the house for a whole year, replenishing it from time to time with new film. The resulting record of the changing seasons in a well-wooded landscape is a *tour de force*.

Red-twigged lime, Shugborough, 1976

Sunderland, 1977
Carousel, Portsmouth, 1977

Aberdeen, 1977

OVERLEAF: London, 1977

A photographer with a good eye will find just as much exotic subject matter in Britain as abroad. Even the most familiar objects can be shown to spectacular effect with imaginative use of light, shutter speed, blurring and blending of colours and choice of angle from which to shoot. On one occasion Patrick Lichfield took a series of shots up and down the British Isles for British American Tobacco. These were later exhibited in various provincial galleries. The picture of Aberdeen at night comprises the bluish-white tones characteristic in the popular mind of a northern city with the bright lights of an oil refinery. Aberdeen in the late Seventies was pre-eminently an oil city of the far north. Gladstone Street in Sunderland speaks of the continuity between the north-east's past,

with its back-to-back houses put up by the acre in the latter half of the nineteenth century and first half of the twentieth, and the pruning back that has been carried out more recently. The rather grim backdrop is balanced by a neatness not to be found in London. A London shot only needs red buses, as on the following pages, to make the location clear. The red streak athwart two examples of more measured communication, the telephone boxes, gives a good idea of the hectic pace of life in the capital after the quietism of Sunderland.

The roundabout horse offers a contrast with the red bus in that it 'goes' nowhere. Yet its portrayal in a blur similar to the bus's gives a sense of movement. Buses travel along a prescribed route or 'circuit' too.

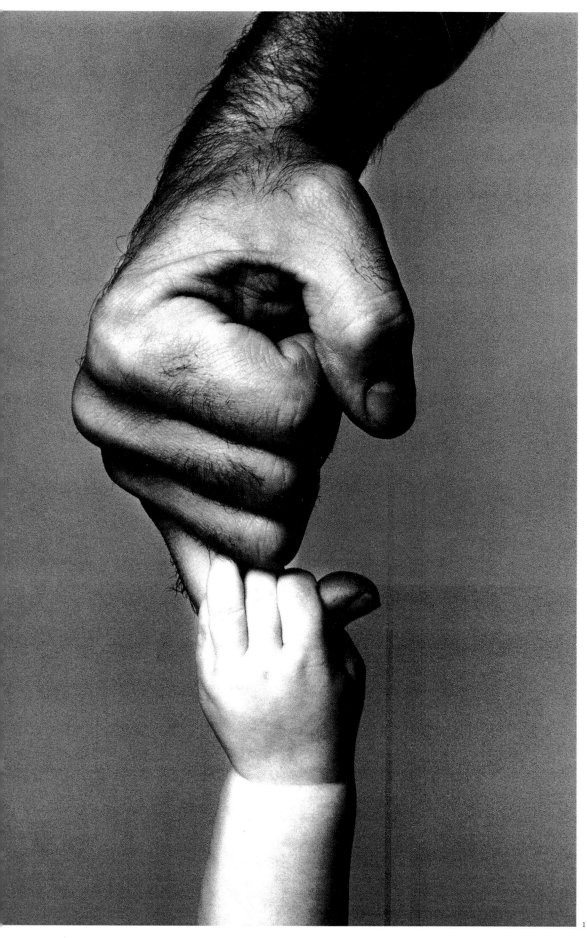

3

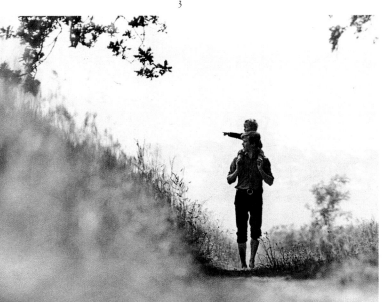

5

When the Bayer pharmaceutical company commissioned Patrick Lichfield to prepare seven photographs to illustrate Shakespeare's seven ages of man (from *As You Like It*, Act II), the results embodied a good deal of artistic licence. Shakespeare's infant is described as 'mewling and puking in the nurse's arms'; there is no face in this depiction of infancy and in others (see, for example, the first page of the book) the baby is a paragon of calmness. Shakespeare's schoolboy is 'whining' and with his 'satchel, and shining morning face', creeps 'like a snail unwillingly to school'; the boys in the photograph (Patrick Lichfield's two nephews, Jonathan and Nicholas Shakerley) look less glum and appear to have arrived at school by limousine.

The student (played by Patrick Lichfield's assistant Peter Kain) is certainly bearded, but in Shakespeare it is the soldier or justice who is bearded, not a student. The old man in the photograph (the actor Harold Bennett) looks a good deal wiser than either Shakespeare's fifth, sixth or seventh age, respectively a 'justice . . . full of wise saws and modern instances' (the kind of JP who blames rising crime rates on sub-standard housing, presumably), a 'lean and slippered pantaloon, with spectacles on nose' and a toothless, memoryless, sightless inhabitant of second childhood. It has to be said that Harold Bennett looks remarkably spry and *compos* for an old man in Shakespeare's terms.

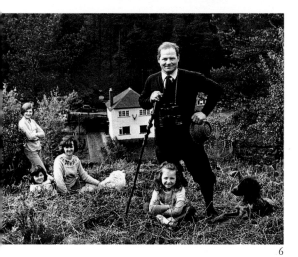

6

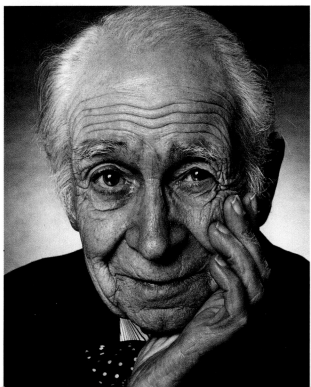

7

Miss Pears, 1977

Patrick Lichfield, it will be recalled, first made his name as a photographer of children. Even in his book *The Most Beautiful Women* he had a picture each of Lady Sylvy Thynne, Sir Walter de la Mare's great-granddaughter Laura, Pandora Stevens (daughter of the former magazine publisher Jocelyn Stevens) and Lady Samantha Feilding, none of whom was more than ten at the time. Miss Pears would have been suitable company for that infants' gallery. (The title derives from the fact that every year the firm of Pears chooses a junior Miss to epitomize the fresh appeal of its product.)

Lady Rose Anson is Patrick Lichfield's elder daughter. The composition here might be by Sir John Millais.

Lady Rose Anson, Shugborough, 1979

Jamaican boy, 1971

'Bubbles', 1973

Spider, 1971

Patrick Lichfield's one involvement so far in making moving pictures has resulted in *Spider*, a short he directed about a tramp who lived out of a pram. It has been shown as an appetizer to the main feature in several cinemas, including the Haymarket in London's West End.

The Asaro tribesman of Papua-New Guinea is seen clutching his piglet, which he said was his most treasured possession. Patrick Lichfield has called this one of his favourite photographs.

Asaro tribesman, Papua-New Guinea, 1972

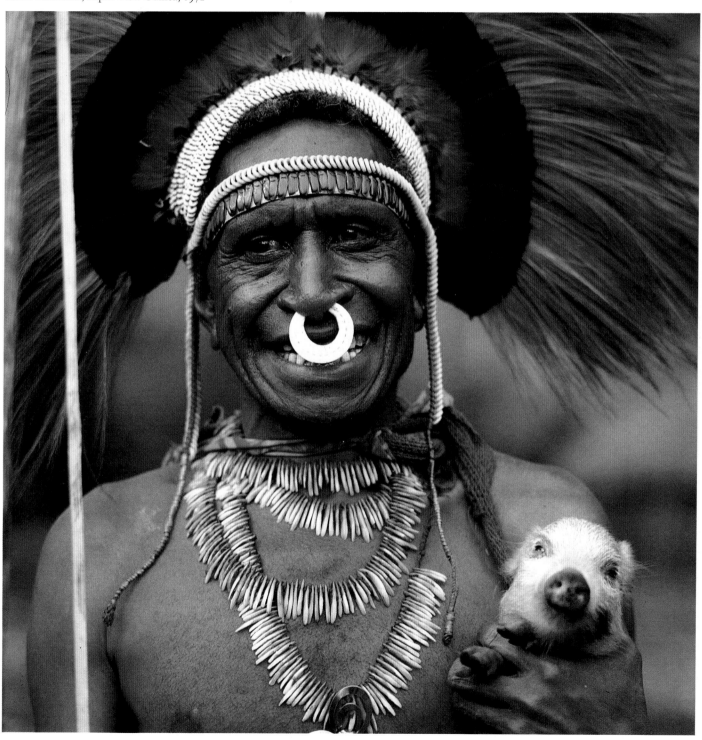

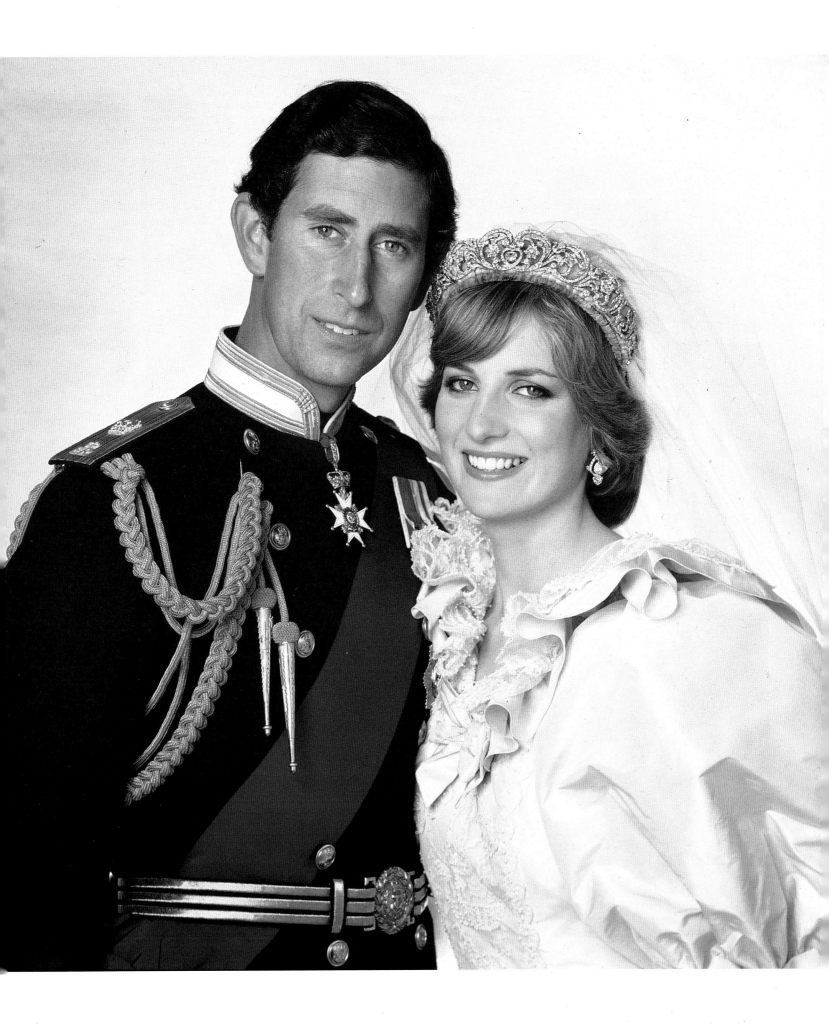

THE
1980s

Patrick Lichfield, 1983

The Prince and Princess of Wales,
wedding day, 29 July, 1981

In Britain as the Eighties got under way it seemed as if a really new broom was for once about to sweep the country clean of the cobwebs from the past. The Sixties and Seventies had been exciting in their way, but now a certain maturity was desirable. It was high time, if national well-being was to be restored. Or so the neo-conservative line went, and this line was in the ascendant. But was maturity practised? There was certainly a new government, one led by the most radical-sounding prime minister since Ramsay MacDonald had first entered Number 10 in 1924. Like Ramsay MacDonald, the new prime minister presently began to seem rather less radical when it came to execution. But the sense of a new dawn was palpable. Britain's long-standing resentment against Europe seemed to have died away, although a vigorously xenophobic streak still infected the

British and occasionally found unpleasant expression, as in the massacre of Italian football spectators at the Heysel stadium in Belgium in 1985. Nevertheless, while there was no great enthusiasm for membership of the Common Market it did seem as if most Britons now accepted that they were in it to stay.

In America, too, a longing to rehabilitate a more traditional outlook was detectable. Ronald Reagan, so astute a politician that he managed to seem simple, at times almost disquietingly so, was elected president just a year after Mrs Thatcher acceded to the premiership. His stay in office has so far been as long as hers, despite his age.

Back in Britain technological development appeared to be winning acceptance at last. In certain matters, possession of video recorders for instance, the British were ahead of everyone else in the world. Certainly the video became an important vehicle of communication, especially in adding physical colour and movement to pop music. A sober optimism gently infused the British nation – not the euphoria of twenty years before, but something more prudent, more tentative. Perhaps because of its low-key quality it seemed more likely to be justified. Dynastically, too, the Eighties started encouragingly. The heir to the throne announced his engagement in 1981. On the international front things looked up. The awkward and long-running burden of Rhodesia was at last shuffled off. Surely these were real reasons for self-congratulation.

Yet as the Eighties wore on it became apparent that Britain was incorrigibly up to her old tricks again, a recidivist nation. She had slipped back into her bad habit of staring fixedly at mementoes of the past, organizing her present behaviour with reference to what had gone before. The process is evident in commercial art – always a sure guide, in its interaction of economic endeavour and fashion, to a given age's character. Television advertisements, posters on hoardings, page layout in magazines, typefaces have become more and more self-conscious, allusive, 'camp'. Commercial art has gone in increasingly for parody, and in order to understand what is being guyed the consumer needs a good working knowledge of cinema from the Twenties to the Sixties, industrial design of the Fifties and the lyrics of the popular song stretching back to Gershwin and Cole Porter, to say nothing of the rock 'n' roll era which started in Britain with the impact of Bill Haley and the Comets. Fashion, whether in clothes, haircuts or music, has undergone a similar development, for personal appearance is now assimilated to commercial art. There has been a Thirties revival, a Fifties revival, a Sixties revival even. It is called Minimalism or Post-Modernism rather than revivalism as such. Indeed Post-Modernism is eclectic as far as it goes, happily mixing elements from different decades to produce its effects. But since it is the very nature of Minimalism to be incapable, by its very paucity of original references that are authentically its own, of ringing any but a few changes, the likeness to the stark lines and uncluttered surfaces of Thirties Streamline, Fifties Austerity or Sixties Progressive has been startling.

Nostalgia for decades twenty years and more before many people have been born is not new. In the early Fifties there was a distinct cult of the Twenties with the success of Sandy Wilson's musical *The Boyfriend* (1953). Then there were the neo-Edwardians and neo-Victorians, demotically

expressed by the Teddy Boys, more sophisticatedly by those whose wicked portraits as self-conscious aesthetes or diehard reactionaries appeared at the time in Angus Wilson's short stories and Osbert Lancaster's pocket cartoons. Yet in the Eighties revivalism has seemed new because there has been so little of it in the two preceding decades. The Sixties sensibly avoided crying up the Forties, for ten years of war followed by shattering exhaustion would have strained the fantasy-generating powers of a Hans Christian Andersen. As for the Seventies, it was too obsessed with prolonging the Sixties to have much time for revivalism. It is true that the ghoulish displays which burgeoned at the end of the Seventies and continued throughout the Eighties in the shape of Punk had precursors in Dada and Surrealism and the Existentialist get-up of Left Bank Parisians in the late Forties and early Fifties. But the Punks themselves are unlikely to have been making a conscious statement along those lines.

The real revivalism has been less arbitrary in its germination and it has not passed the young by. The young are always more prone than their elders to enthusiasm for the past if only because they have lived through less of it. And it is true that this revivalism is visually expressed principally by the young, for they continue to have enormous spending power compared with previous generations at their age, and the young in modern times have been readier than their parents to spend their leisure in public – the street, the disco, the ice rink.

This revivalism, however, has more to do with commerce than youthful histrionics. The concentration on the recent past – the mini-skirt of the mid Sixties, the black tights from the early Sixties, the ballet student haircut from *circa* 1960 for girls; the demob haircut look *circa* 1960, the Russian student cap *circa* 1965, the generally clean-cut college kid (archetypally the Beach Boys) from the mid Sixties for boys – reflects a view of the Sixties with enormous appeal to the immediate post-war generation that actually lived through it. After all, it is largely this generation that controls the advertising and clothing industries and can therefore push this line most forcibly.

As a force for drastic social change this generation, born during the years roughly from 1939 to 1953, has been grossly underestimated. Their luck – they were born either after the war or, if before it, were young enough at any rate to enjoy the spreading prosperity of the Fifties – has made them confident, even bold. They are talented and quick of mind, perhaps because as a generation they were the first children to enjoy proper nutrition. They have not always possessed a spirit of integrity, but that has not necessarily been a handicap given the high stakes they played for in the Sixties. What this generation did in those years was effectively to overthrow the society ruled by its elders. It was done in the most insolent and seemingly insouciant fashion, yet it was devastatingly successful. By some extraordinary trick of timing or luck or pressure on the right spot, the youth *putsch* worked. By 1969 the younger generation had seen off a civilization which, by investing fathers and grandfathers with moral authority, had maintained a very real continuity with preceding generations all the way back to classical antiquity. The Sixties generation proceeded to make itself master of the entertainment world, advertising, the arts, fashion, public relations – all the communicator professions

in fact. With these it then propagandized on behalf of its generation – its hedonism, its liberalism with a small 'l', its disrespect for authority, its love of the flashy.

They might have been expected to fall victim to their own young in turn, for revolutionaries are proverbially devoured by the revolution they instigate, but the extraordinary thing is how much of the pace in the Eighties has still been set by veterans of the Sixties. Those who have survived from that era have shown themselves to be still vigorous. They have by now added to their tenancies in the communications sector substantial positions of power in more 'serious' walks of life. Their ascendancy has not been threatened by the relative inertia of their own children, despite those children's obvious concern for material advancement, because in the first place the Sixties generation's children lack the spark their elders had. Secondly, the Sixties generation has fed its own young the broadly progressive education that has been one of the fruits of Sixties theories. The Sixties generation's insistence on permissiveness and creativity in education has been genuinely idealistic, but it has had the very convenient practical consequence for the Sixties generation that those who have become full adults in the Eighties are less literate and numerate than their parents. This has allowed the Sixties generation to hang on to power.

It might be argued against this analysis that ever since the Sixties revolution the ageing have been struggling against their children on the latter's terms. Certainly no other generation has fought such a rearguard action against ageing. In the Eighties the Sixties generation have tried harder than any other in history to keep their figures and their hair and their unlined faces. They have continued to dress in young men's and young women's styles long after any previous generation entering middle age would have given up the effort. They even take part in young people's sporting activities. Recreations such as skiing, windsurfing, disco dancing or tennis which have flourished in the Eighties – the cult of personal participation in sport – are pursued as eagerly by the ageing hipsters who came to maturity in the Sixties as by their children. An example from the world of clothing is once again instructive: the astonishing longevity of denim as a material. Jeans have now been in fashion in one way or another for a quarter of a century. Denim is peculiarly the material of the Sixties generation. The fact that it is hard-wearing is not really an explanation for its continuing popularity, which arises more from an association with rugged, outdoor, physically active people.

It would have looked pathetic if only a handful of greying trendies had striven to look young past their rightful moment for doing so. Because the generation born between 1939 and 1953 is so populous, however, particularly the post-1945 cohort, it has simply outnumbered every other generation. It was a demographic coup that made the social one possible. The Sixties generation has kept itself young in manner and appearance remarkably successfully. It may have fought its own young in the idiom of youth, but it has had twenty years of training in how to think young, act young, talk young. On the other flank – for it has fought on two fronts – it has brought to the task of outwitting physical senescence all its faith in its own triumph. The Eighties crazes for aerobics, jogging, tiny helpings of food dictated by *nouvelle cuisine*, fizzy water and polyunsaturated

butter substitutes are naturally explicable as the neurosis of middle age. But why did not such preoccupations hold the centre of the stage before? The answer is that only now has the most ruthlessly self-centred and propagandizing generation in human history reached middle age.

After the Swinging Sixties and Consolidating, or Cementing Seventies, the present decade might be called the Expiatory Eighties. As well as its tendency to self-imposed austerity, expressed by physical fitness fads, bills are starting to come in for the overindulgence of the Sixties and the frenetic attempt by latecomers in the Seventies to prolong the party. Many of the problems of the Eighties in Britain – university funding, disaffected inhabitants of squalid and impersonal housing estates, pollution – are results of theories applied too enthusiastically in the Sixties.

The term expiation should not be taken to mean contrition. The Sixties generation has not invariably been sorry for what was done in the Sixties, however eager it is to minimize the evil consequences. A drunk who regrets the debauch of the previous night because it gives him a headache may well go out and get drunk again the next night. If he does this habitually it is difficult to think of him as having entertained any lasting repentance. The Sixties generation in Britain still controls vast swathes of the communications industry. Broadcasting, particularly Channel 4 under its first chief Jeremy Isaacs, newspapers such as the *Observer* and the *Guardian*, weeklies such as the *New Statesman* and *New Society* and the two London listings magazines *City Limits* and *Time Out*, have all remained committed broadly to causes the Sixties championed. It is doubtful if the neo-conservatives – known as Young Fogeys – number more than 20,000 at the very most, for all the satirical press comment devoted to their fondness for bicycles, tweed suits, Victorian open-grate fireplaces and the glories of traditional architecture.

The genuinely young in the Eighties have not been entirely ready to knuckle under to the outlook inculcated by their elders, all the same. They have been much less keen on fizzy water, preferring fizzy soft drinks or furtive and sometimes illicit experiments in drunkenness – under-age alcoholism has become a topic of serious concern in the Eighties – or, saddest of all, drugs. And the young have evidently been less prepared to put up with *nouvelle cuisine* at restaurants; nor has this been because they are less interested in going out than their parents. Cocktail bars have suited them for socializing, but the fast food takeaway outlet has made enormous strides in popularity in the Eighties. The genuinely young like to eat on the trot so as not to miss what is going on in the streets.

The Punk phenomenon has been the most eye-catching way of showing dissent from the values of the Sixties generation now in control, but it has been found to have fewer possibilities than its spectacular qualities promised. Neo-Romanticism has been a more successful tactic, partly because it has allowed for a whole range of attitudes to be adopted, not just clothes and make-up and jewellery. Cocktail bars are one manifestation of this, the revival of the tea-dance another. The cult of the butterfly-wing collar for evening wear and the Rupert Brooke haircut for men, of the black dress and Russian Cossack hat for women, are other neo-Romanticist pointers. There have even been signs in the late Eighties of a cooling enthusiasm for the solitary spasms involved in the physical act of

disco dancing. Big bands have begun to make a comeback. There have been signs of a return to more formal, intricate dancing – a skill which has to be learnt. It may be too early to say, but an event such as the Winterhalter Ball, a costume party on an 1840s theme which was held in the early winter of 1987–8, could one day rank with the first Post-Impressionist Exhibition in Britain in 1910, or the first night of Victor Hugo's play *Hernani* in 1830 (the event which marked the arrival of the Romantic Movement in France), as a turning-point in aesthetic history.

America has still been exerting her influence on Britain, and the enormous success of a British television series such as *Brideshead Revisited* in the early 1980s can still from time to time work the old magic in Americans. But there remain vast areas in America that repudiate Europe – not so much on the grounds of its corruption, as was once the case, as on the grounds of its irrelevance. The rise of Japan and other Pacific basin economies interests many Americans more than Europe, for most Americans have been practical-minded traders first, historically minded second. Their ancestors would have been less likely to emigrate to America had they been otherwise.

Oddly enough, the visions of America most enthralling to Britons have been the fictions of powerful families on television that derive chiefly from a European tradition. This genre of dynastic intrigue was in historical fact an invention of the Italians, with the Julio-Claudians and Flavians in ancient times, the Borgias and Medicis in the Renaissance, then spreading north with the Bourbons, Habsburgs and Romanovs. In Britain the Whig magnifico houses rather than the reigning dynasty supplied the drama once the Stuarts left. Indeed *Brideshead* was the last flickering of the flame in precisely such a family. But now the idea has returned to Europe via America and that country's technically superb if artistically null television industry. It is an ominous portent.

Although the Eighties are not over, it is safe to say the royal wedding of 1981 will hold its place as one of the supreme visual memories of the decade. If all ceremonial and personal content were drained from the picture of the Prince of Wales standing beside his crouching bride, it would remain a highly satisfactory composition. Even the Bloomsbury Group art critic Clive Bell, whose austere doctrine of significant form taught the eye to look for shapes and tonal values and their interrelation rather than subject matter, would surely have approved. The spiral nautilus shell patch of white (the wedding dress and train) makes a felicitous counterpoint to the heavy backdrop and perpendicular figure on the left of the picture.

The minor characters as well as the principals at the royal wedding showed on the whole great poise during the public moments. Inevitably there was more spontaneity

The Prince and Princess of Wales, Buckingham Palace, 1981

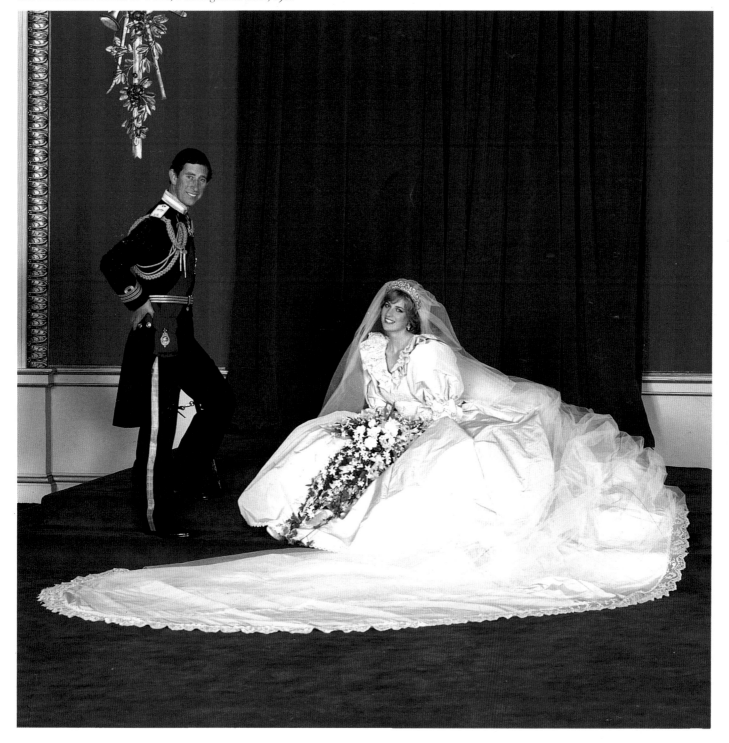

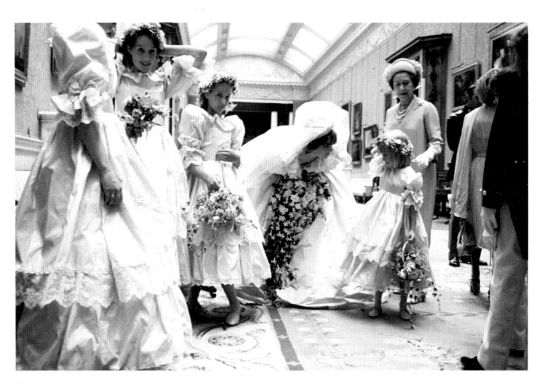

Behind the scenes, Buckingham Palace, 1981

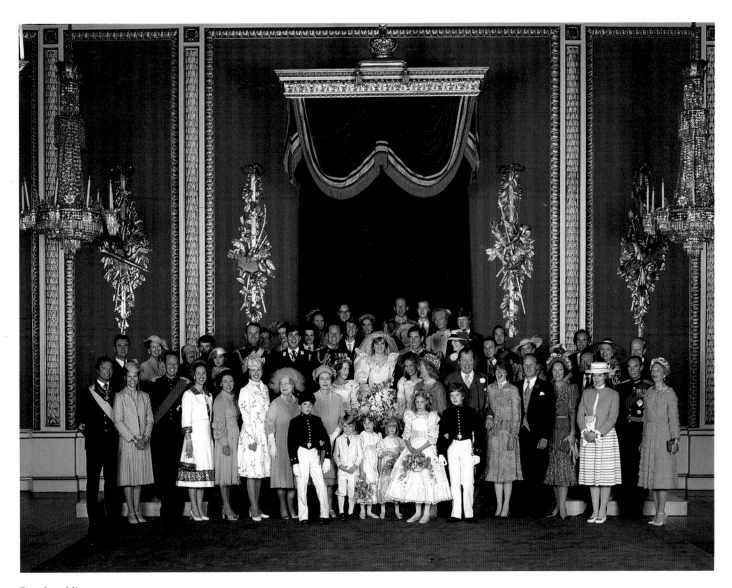

Royal wedding group, 1981

behind the scenes, particularly as exhaustion took its toll. In an informal picture the Princess of Wales reverts for a minute or two to her former professional role looking after children in order to comfort one of her bridesmaids, Clemmie Hambro. Miss Hambro's great-grandfather, Sir Winston Churchill, was also given to outbursts of personal feeling, frequently involving tears, on state occasions.

Patrick Lichfield has said that although the formal wedding group of bride, groom and chief guests was necessary for the historic record, it was in his opinion the least interesting picture he took that day. The historically minded may think otherwise because the royal family of Britain is seldom seen all together, and virtually never with the other sovereigns of Europe and their consorts as well.

The Prince of Wales in Garter robes, Windsor Castle, 1985

The climax of these royal photographs is undoubtedly the Prince of Wales in full Garter robes at Windsor. The Garter is the highest order of chivalry in Britain and although the precise date of its founding is uncertain one of the most frequently mentioned is 1348, 600 years before the present Prince of Wales's birth.

Probably all families like to think their group snaps are interesting as historical records. In the case of royalty the composition is not only a matter for history but also one of state. The photograph of Princess Alexandra and her family was a purely private commission, however. The combination of bracken and kilts suggests a Scottish setting, but they were in fact grouped in Richmond Park, on the outskirts of south-west London where the Ogilvys live in Thatched House Lodge, granted them by the Queen.

Lord Glenconner was always pictured by the popular press as living the life of a nabob on his Caribbean island of Mustique. Here he is seen in a composition which, with two black boys in attendance, is pure Zoffany. He is an old friend of Princess Margaret, and his wife, formerly Lady Anne Coke, a daughter of the Fifth Earl of Leicester and a cousin of Patrick Lichfield, has been a lady-in-waiting to the princess.

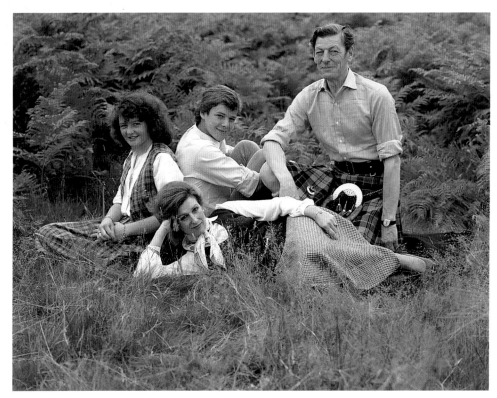

Princess Alexandra and family,
Richmond Park, 1980

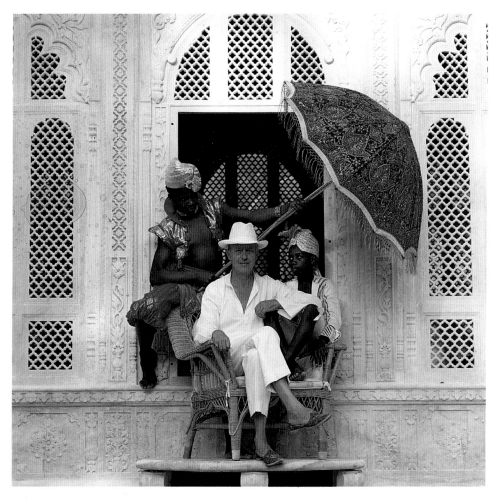

Lord Glenconner, Mustique, 1985

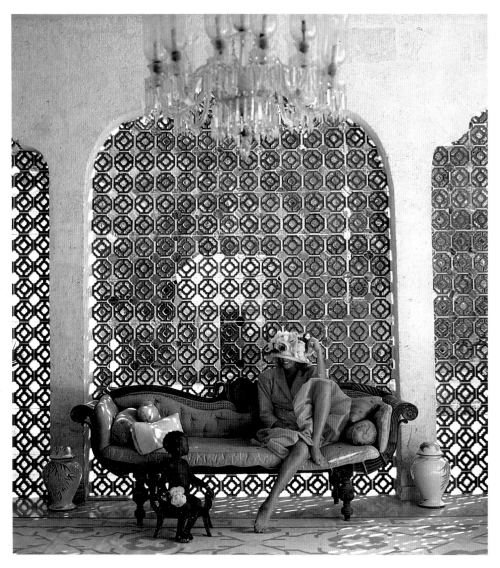

Mustique interior, 1987

Inside Lord Glenconner's Mustique house the atmosphere is almost operatic – the harem as envisaged by Mozart in *The Abduction from the Seraglio*. The very discordancy from a purist's point of view of the chandelier against the scalloped arches and latticework backdrop of Ottoman interiors is all the more reminiscent of a stage set. The small black figure recalls Strauss's *Der Rosenkavalier* rather than Mozart, though the costume is disappointingly skimpy. It is doubtful if inhabitants of an authentic seraglio would have been allowed to adopt quite so sprawling a posture as the model's.

The formality of the model out of doors on Mustique is in sharp contrast. The occasion was Dunlop's centenary, to be commemorated by a calendar for which this was the August picture. The centennial solemnity possibly explains the sobriety of her demeanour and the quantity of dark

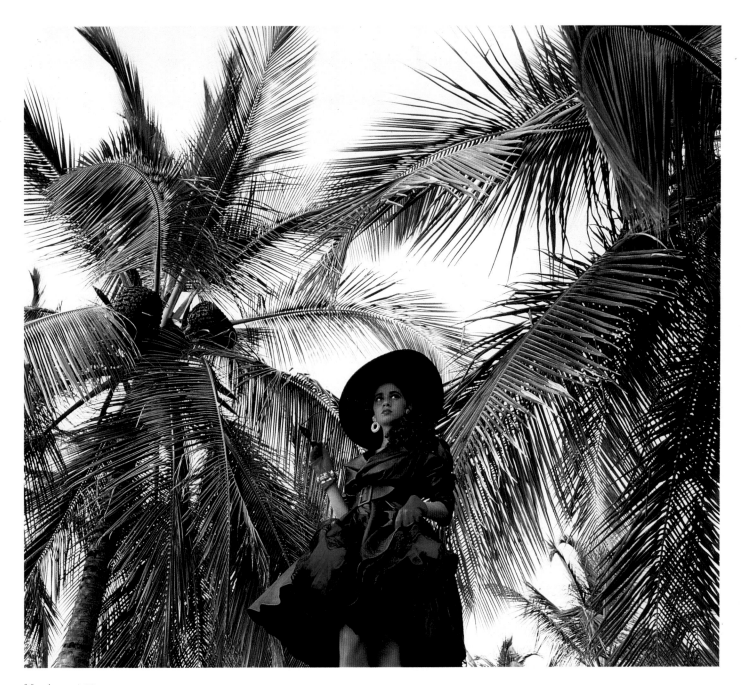

Mustique, 1988

clothes, all the richer and more unusual for their setting against tropical palm fronds.

The girl dancing through palm trees, on the next page, looks less like a character in an opera, even a member of the chorus, than a stray trouper from the *corps de ballet* on whom the scene changer has mistakenly rung down the set for *South Pacific* instead of the gloomy northern forest of *Swan Lake*. One can imagine the ballet being danced beside a tropical lagoon and the fantasy upheld by Lord Glenconner himself, who ruled the island of Mustique in the Sixties and Seventies as completely as the magician Rothbart ruled his wildfowl reserve in the *Swan Lake* legend.

OVERLEAF: Mustique, 1987

Lake Baringo, Kenya, 1981

Sharba, Kenya, 1981

Pont-sur-Seine, France, 1983

Pont-sur-Seine, France, 1983

Twelve-metre yacht *White Horse*, off Sardinia, 1988

Water of one sort or another is a favourite backdrop for Patrick Lichfield's photographs of women. The impression that the yachtswoman, taken for White Horse whisky, is alone is misleading as a small army of deckhands lay just out of sight in the cabin of the twelve-metre yacht.

The winged keel was the secret weapon that helped Australia win the America's Cup for the first time in its history, in Newport in 1983. Dennis Connor's American team retrieved it in Fremantle in 1987, beating the New Zealanders, whose keel this is, in the semi-final.

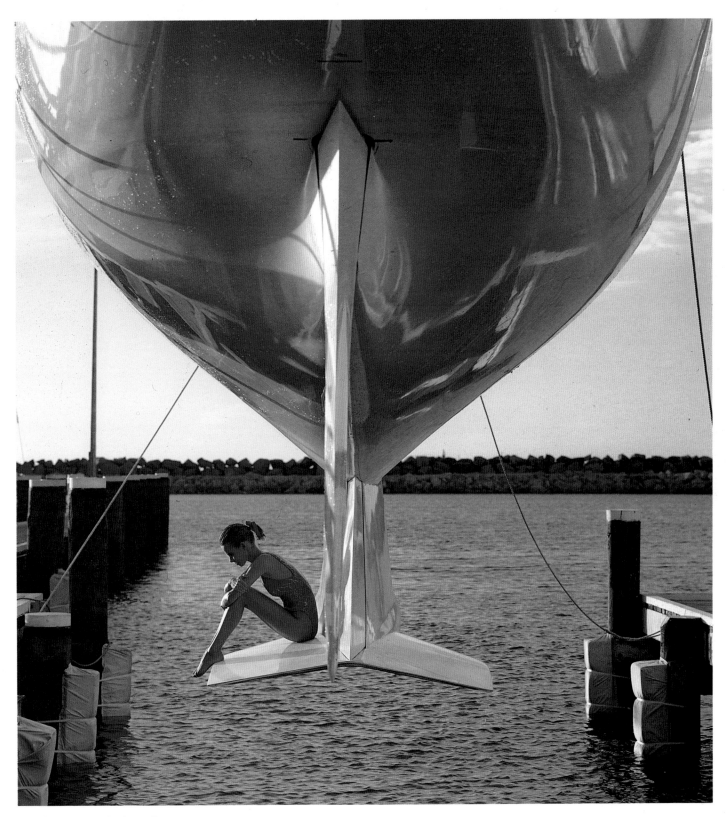

KZ3's keel, Fremantle, Australia, 1987

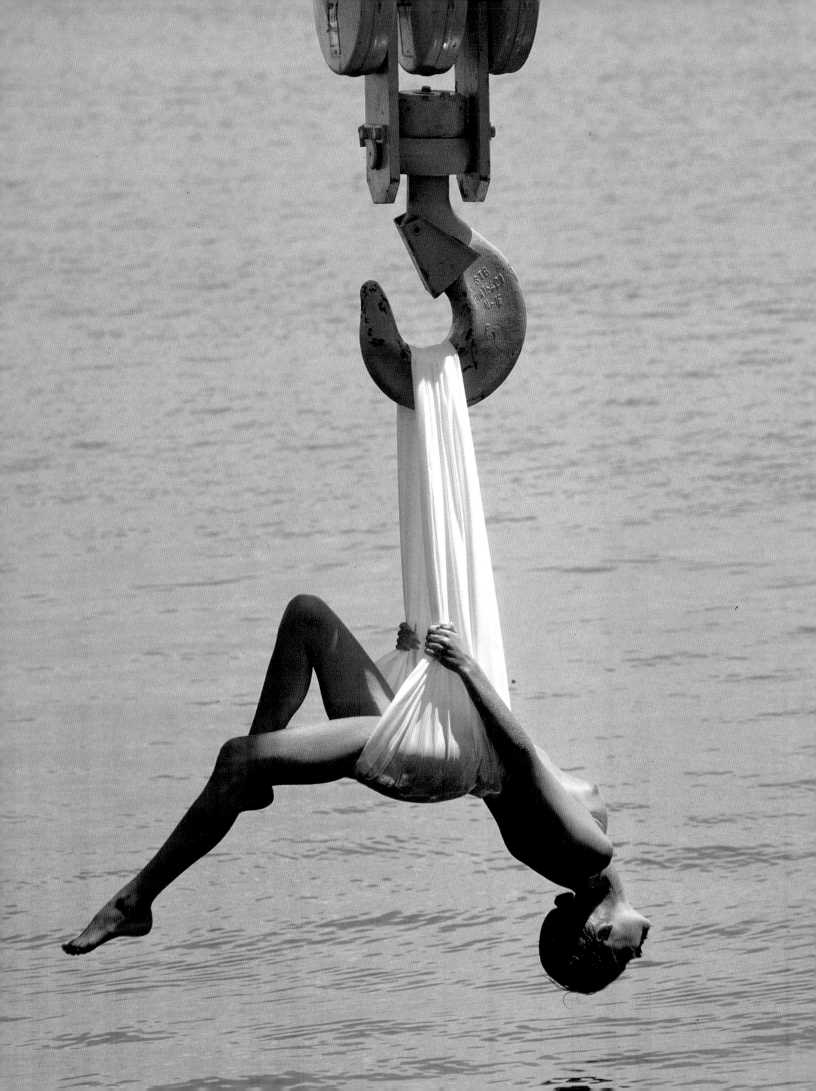

The piquancy of the photograph of the girl on the hook lies partly in the contrast between the industrial brutishness of the hook itself and the carefully filed and painted fingernails of the 'catch'. The lifeguard with his burden shows a similar contrast – his strength and her surrender.

Fremantle, 1987

Fremantle, 1987

Palazzo interior, Sicily, 1982

Ibiza, 1984

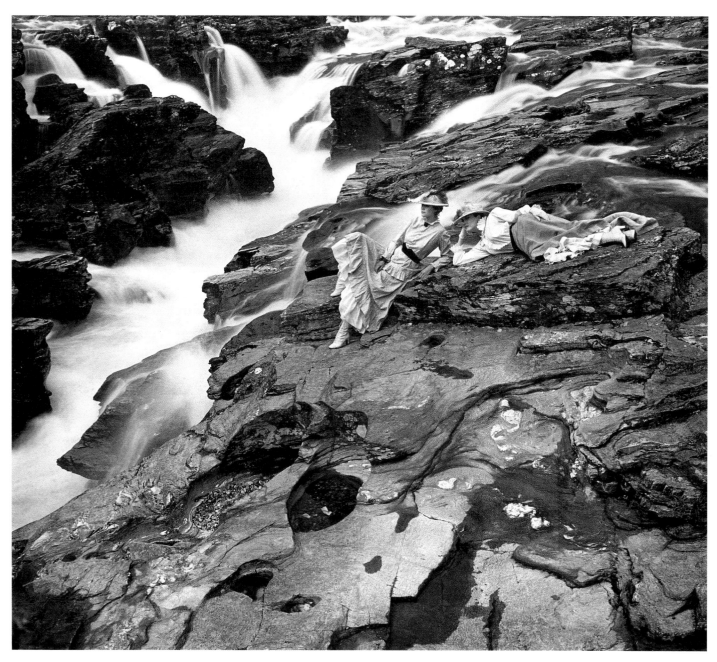

Glencoe, Inverness-shire, 1988

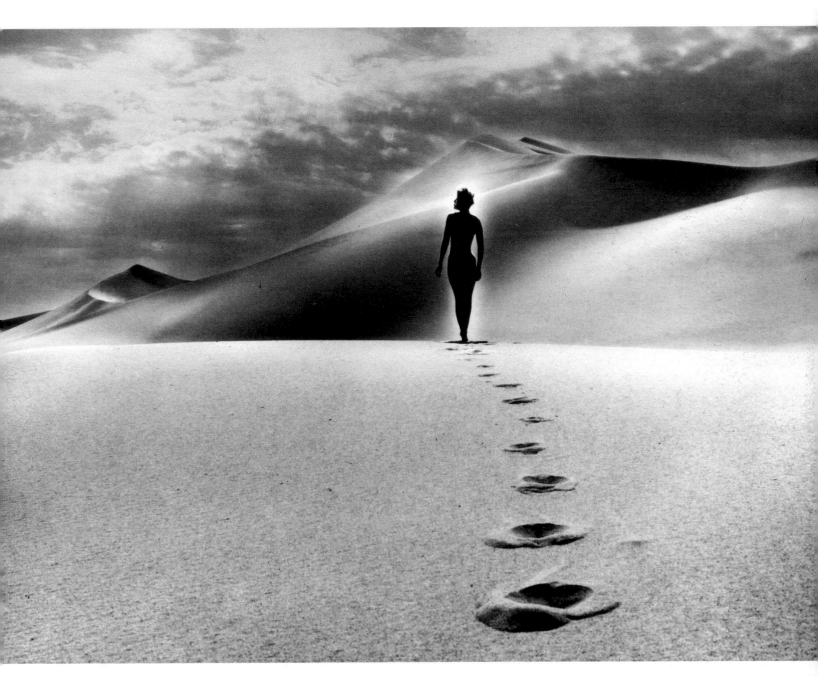

Death Valley, California, 1986

Imran Khan, 1982

Imran Khan, the Pakistan-born cricketer, has played for Worcestershire and Sussex as well as for the country of his birth in foreign tours. In the spring of 1988 he came out of retirement at the request of President Zia and captained Pakistan in the Test match against the West Indies, at one point taking 7 wickets for 80 runs. He captained Oxford when up at Keble College, and during one match between Oxford University and Nottinghamshire scored two centuries.

Daley Thompson was the British gold medallist in the decathlon at the Olympic Games in Los Angeles in 1984, where he set an official world record, though he has set personal records that are still better. Such are the demands of the decathlon, including sprinting and middle-distance running, javelin and discus throwing, high jumping, pole vaulting and hurdling, that Thompson has a good claim to be the best all-round athlete the world has ever seen.

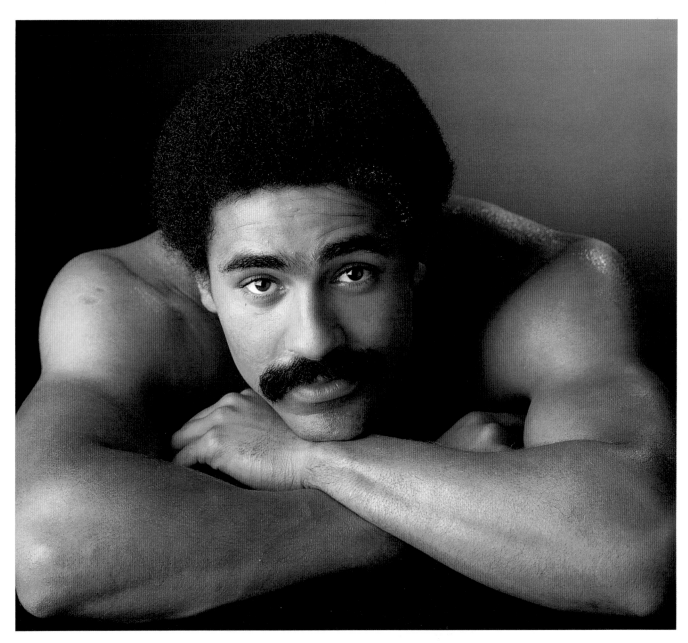

Daley Thompson, 1982

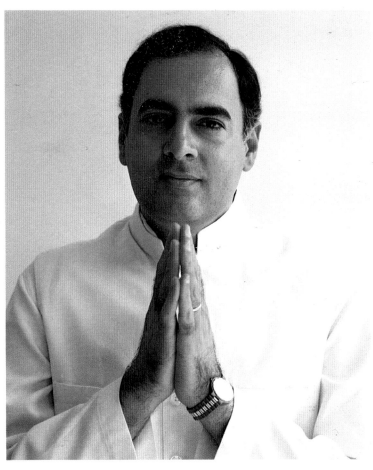

Rajiv Gandhi, 1985

Rajiv Gandhi, seen here making the Hindu sign of peaceful greeting, has been fortunate enough to head a country whose devotion to peace is widely recognized. The photograph was taken for the first issue of *Kohinoor*, a short-lived Indian news magazine conceived along the general lines of *Time*.

Given that Bob Geldof has very deliberately avoided capitalizing on the possibilities his philanthropic work raises for easy sentimentalism, this photograph is subtly posed. It depicts a wistful man, not at all the ill-shaven, over-plain-spoken scamp with a heart of gold that the world would recognize. It is not exactly hagiographic, but a faint religiosity is detectable.

When Clement Freud (now Sir Clement Freud) was elected to Parliament, the occasion was attended by a certain mood of frivolity. Before becoming MP for Ely in 1973 he was better known for his television work in advertising dogfood than for his descent from Sigmund Freud. Neither seemed an obvious qualification for membership of Parliament. As a legislator he worked hard to reverse the earlier impression the public had of him and when, having lost his seat in the Alliance rout of 1987, he was knighted, it was in recognition of his steady work on behalf of his constituents. This photograph is one of a series of famous people dressed as their favourite characters in history. Despite his efforts Sir Clement doesn't really manage to shake off a strong resemblance, less to Gladstone than to the man whose mother reluctantly employed Gladstone, Edward VII. The picture was taken in the National Liberal Club.

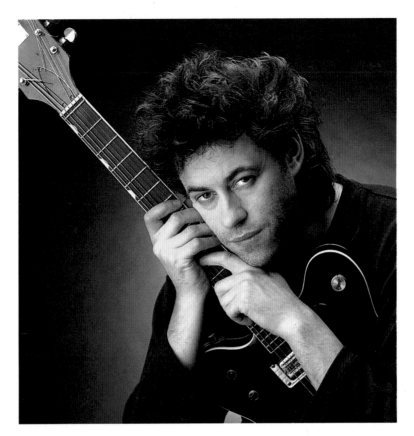

Bob Geldof, 1986

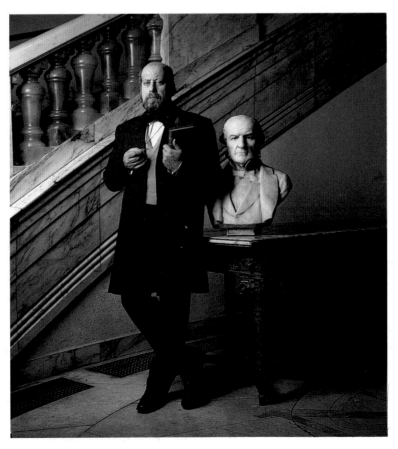

Clement Freud, National Liberal Club, London, 1980

Barry Humphries started off in Britain as an extrovert Australian immigrant to London in the early Sixties. He became a national figure – conceivably he is now a world one – by obsessively raking over his Australianness in public. The author of the Barry McKenzie cartoon which ran for some two decades in *Private Eye*, he invented not just one major *alter ego* – Dame Edna Everage – but two, the other being Sir Les Patterson, the Australian cultural attaché. It is never absolutely clear who is laughing at whom when Dame Edna or Sir Les confronts an audience. Although Barry Humphries likes to describe his act as that of a music-hall artiste, comparisons with the great impersonators of the past – Dan Leno for instance – seem to miss a few nuances. What can be stated confidently is that without Britain and its complex mixture of guilt and condescension towards Australia Barry Humphries' activities would be pointless. To have launched them in Australia itself might or might not have worked in box-office terms, but it would have been artistically sterile. There is sometimes a faintly uneasy sense that the joke has been carried too far, and carried on for too long; not so much beyond the point at which the audience may have ceased to laugh, as beyond that at which the impersonator himself can view his act with some shreds of objectivity.

In the past Barry Humphries has given first-rate performances as Envy in the underrated Faustian allegory

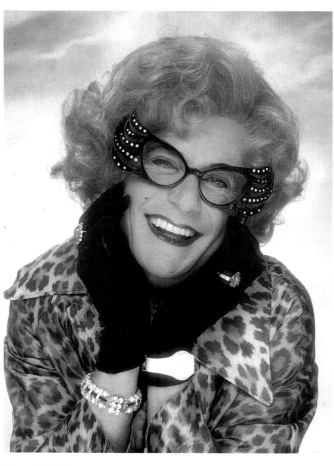

'Dame Edna', 1987

Barry Humphries, 1987

Bedazzled (1968) and as himself in one or other of his personae in two films about Barry McKenzie.

Tommy Cooper was known for conjuring tricks that never went quite right, also for his fez. The latter might seem irrelevant to his stage character, except that the gully-gully men who used to pester travellers at Port Said were very poor conjurors. His expression here suggests a dragoman in tarboosh given to a bit of tomb-robbing on the side and now confronted by a vengeful mummy awoken from forty centuries of rest.

Sir John Mills has been connected with the entertainment world since, as a boy, he appeared in the chorus of a revue during the late Twenties. Subsequently his principal roles seem to have been those of British officers in a succession of films about the Second World War. He was fortunate in coming to full professional maturity at a time when the war was over but sufficiently recent to make it highly acceptable entertainment. Throughout the Fifties and Sixties war films were turned out in profusion. Yet by surviving into the Seventies and Eighties he managed to become the epitome of decency on the screen at a time when it was in ever shorter supply. He was knighted in 1976, the honour setting the crown on a career that had become patriarchal off the screen as well: his daughters Hayley and Juliet both became actresses. He won an Oscar for his part in *Ryan's Daughter* (1970).

Tommy Cooper, 1980

Sir John Mills, 1980

Sir Georg Solti, 1982

Sir John Gielgud, 1988

Sir Georg Solti, who was born in Budapest, was originally a pianist as well as a conductor. He also studied composition, his teachers including Béla Bartók and Zoltán Kodály. He first made his mark on the world by winning the International Pianoforte Competition in Geneva in 1942. Since the war he has been musical director of the Bavarian State Opera, the Frankfurt City Opera and the Royal Opera Covent Garden. He is currently chief conductor of the Chicago Symphony Orchestra. He is particularly admired for his interpretations of Mozart, Wagner and Richard Strauss.

Sir John Gielgud is Britain's premier theatrical knight. His Shakespearian and other roles are too numerous to list but are sufficiently celebrated. It is less well known that he has directed both plays and operas, including Benjamin Britten's *A Midsummer Night's Dream* at Covent Garden in 1961 and Mozart's *Don Giovanni* at the Coliseum in 1968. His long acting career was crowned with an Oscar for his performance as a valet in *Arthur* (1982).

Now that there are so few reigning sovereigns left – and among those who do survive three are queens – the only place where an assembly of grim-faced kings is likely to be encountered is the stage. The ensemble here consists of the principal actors in 'The Kings', a series of Shakespeare's historical plays.

The English Shakespeare Company's 'The Kings':
(left to right) John Castle, Michael Pennington, Paul Brennan, Andrew Jarvis, 1987

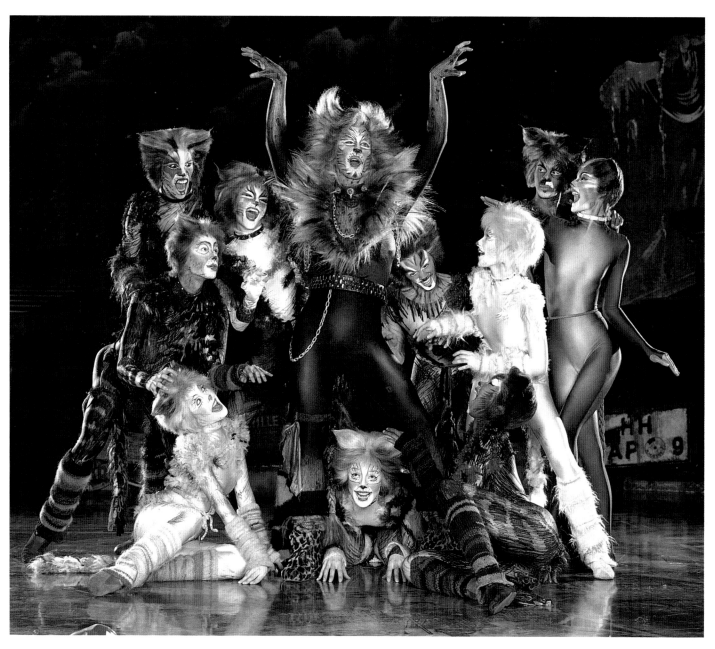

Cats, Operettenhaus, Hamburg, 1986

Stephanie Powers, 1984

Despite the intense Englishness of T.S Eliot's poems in
Old Possum's Book of Practical Cats (1939), which formed
the basis of the musical *Cats* (1981), the Hamburgers
snapped up the show eagerly. The photograph was taken
as one of a number of illustrations for the theatre
programme when the show went to Germany.

Stephanie Powers is chiefly known as a television
actress, having starred in the mid Sixties in *The Girl from
UNCLE*, an attempt to prolong the interest in spies already
fostered by Robert Vaughn in *The Man from UNCLE*. Later
she played opposite Robert Wagner in *Hart to Hart*, a
television series about a husband-and-wife detective team.
She is most likely to be remembered for her association
with William Holden off-screen, however. To
commemorate him she organized the building of a wildlife
hotel in Kenya and, illustrating her enthusiasm for
wildlife, posed between two tiger cubs.

Ballerina, 1983

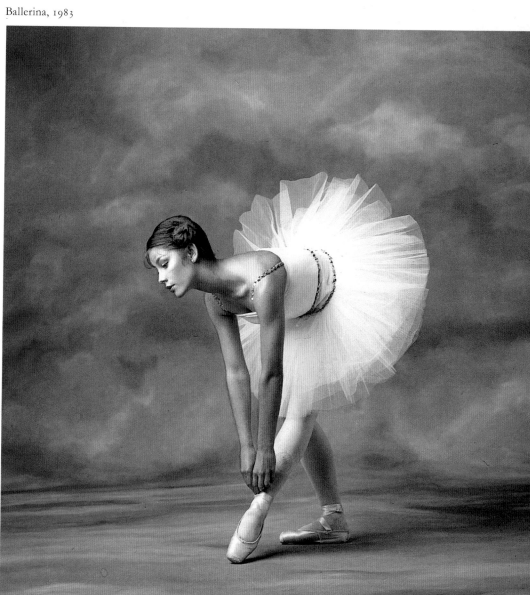

Georgina Stroud, Sydney, 1986

Morgan Fairchild is another television actress, the latest in a long but essentially modern line of the breed to make their names in soaps (*Flamingo Road* in her case). This is surely the real triumph of television over cinema. It doesn't seem to matter that the soaps are conceded to be hokum dramatically; the breathtaking appearance of the actresses has brought glamour back to the screen – a trick the cinema has become too pretentious to attempt any more. In the old days stars were made on film, not television; at best the successful television performer would be a comedian or quiz-game compère – in either case a being with limited geographical appeal. By concentrating on visual appeal – not just good looks but clothes, make-up, jewellery – the television soaps have stolen from the film industry the ability to make international stars. Never mind if they are dramatically immature – so were most of the films of Hollywood in its golden years. Morgan Fairchild has become a name to an extent out of all proportion to her modest showing in *Flamingo Road*, itself a modest offering. Part of the explanation is that good looks and glamorous clothes are international in appeal, whereas the enjoyment of plot and dialogue is limited to those with a grasp of the nuances of language and dramatic narrative.

Jane Birkin, pictured on the next page, comes from a 'good' English family – it has been headed by baronets since 1905 – but decided to live in France twenty years ago. She was one of the romping, puppyish half-naked teenage girls who invaded David Hemmings's studio in *Blow-Up* (1966), that characteristic Sixties film about a photographer's life. Later she starred in a film called *Je t'aime, moi non plus* (1976) and made a pop record which, with its over-heavy breathing, got itself banned in various places. Her most recent film was directed by Agnès Varda and is called *Jane B. par Agnès V* (1988). It is part documentary, part drama and in it Jane Birkin and Agnès Varda discuss how they will make a second film, called *Kung Fu Master* (1988). In the latter film Jane Birkin

seduces a boy of fourteen (played by Agnès Varda's real-life son) who is a friend of her screen daughter (played by Jane Birkin's real-life daughter).

Anouk Aimée always gives the impression of being a *grande dame* of the cinema. This is not only because of her appearance, but because of her parts in classics such as Fellini's *La dolce vita* (1960) and *8½* (1963). To the resolutely English-speaking world, however, she is best known for her parts in *Justine* (1969), based on the Alexandria novels of Lawrence Durrell, and Claude Lelouch's *Un homme et une femme* (1966). In the latter she played opposite Jean-Louis Trintignant. Claude Lelouch won an Oscar for his direction, and inasmuch as most critics complained that the film owed its appeal to his skill in dressing up a slight story by means of colour filters and other lyrical gimmickry amounting to artful technique, it was clearly justified. Anouk Aimée was nominated for an Oscar for her part in the film. She married as her fourth husband the British actor Albert Finney, a surprising choice to that large number of people who judge actors by their screen personalities. The marriage lasted eight years, a respectable length of time by the film world's standards.

The name of the actress Jane Seymour might have been designed with royal roles in mind, since Henry VIII's third wife was also a Jane Seymour. Here she is costumed as the Duchess of Windsor (like Henry VIII a person much given to serial monogamy, as the sociologists like to call it, though staggered polygamy is as near the mark). The television dramatization of the relationship between the Duke and Duchess of Windsor starring Jane Seymour was broadcast in early 1988. Jane Seymour's facial resemblance to the real-life duchess, even when taking into account the skill of the make-up and costume departments, is uncanny. She has also appeared in the films *Young Winston* (1972), *Live and Let Die* (1973) and *East of Eden* (1981) and at the time of writing has been announced as the star of a television mini-series about the greatly revered opera singer, Maria Callas.

Morgan Fairchild, 1983

Jane Birkin, Paris, 1983

Anouk Aimée, Paris, 1983

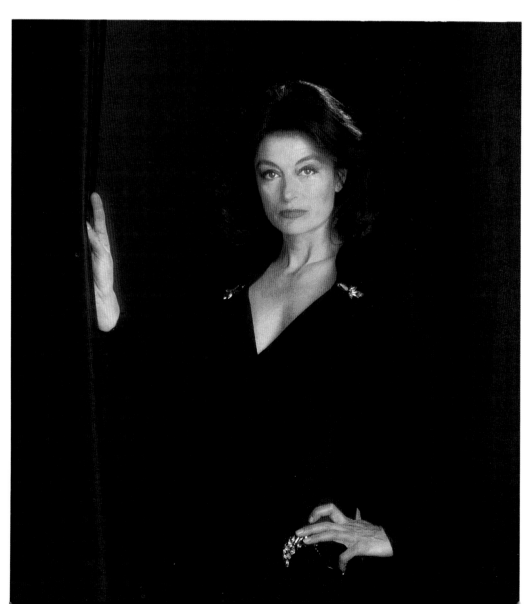

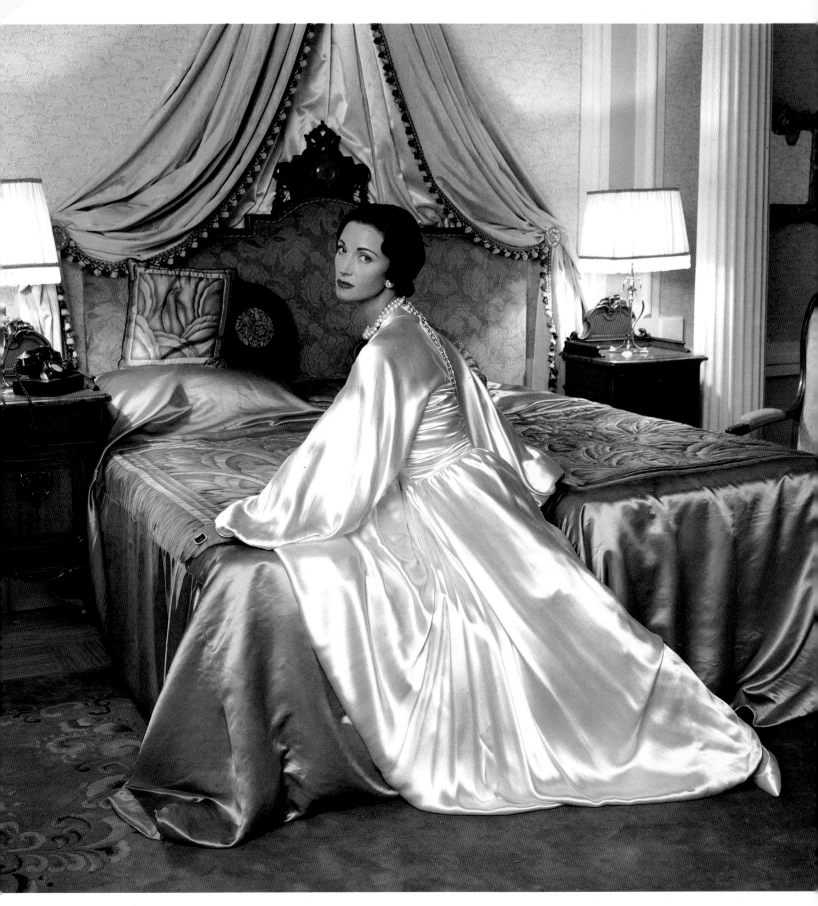

Jane Seymour as the Duchess of Windsor, 1987

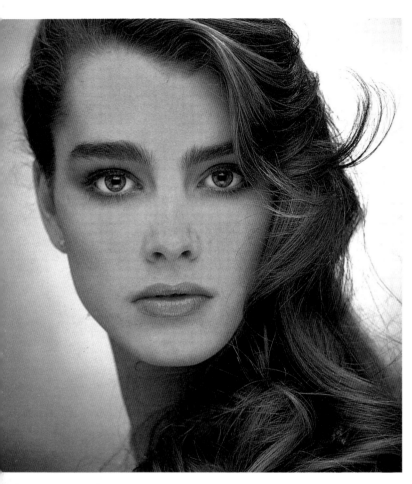

Brooke Shields, 1980

Brooke Shields first came to prominence in *Pretty Baby* (1978), playing a child growing up in a New Orleans brothel. Just as a bullfight is less about the death of the bull (or the torero, as the case may be) than the elaborate ritual leading up to it, so this film was less about the eventual deflowering of a moppet than the lip-smacking preparations for it. Subsequently Brooke Shields grew so tall that when she played standing opposite Christopher Atkins in *The Blue Lagoon* (1980), which involved adolescents discovering each other's capacity for offering sexual gratification in a fantasy landscape, she had to be placed in trenches to avoid towering over him. The camera shots avoided anything below the waist on such occasions, although some critics complained that on others they more than made up for this self-denial.

The model Iman is probably better known in the United States than Britain. Wherever she works she bears just the one name, like Twiggy. She does have another name, Haywood, although she was born Iman Abdul Majid. She is one of those aloof beings for whom the use of both names seems somehow inappropriate, as with royalty. Any impression of aloofness is physiological rather than part of her character and derives not only from her slender, lofty build but from her extraordinarily long neck. As well as modelling she has acted in a film, *The Human Factor* (1979), based on a novel of the same title by Graham Greene.

Iman, 1980

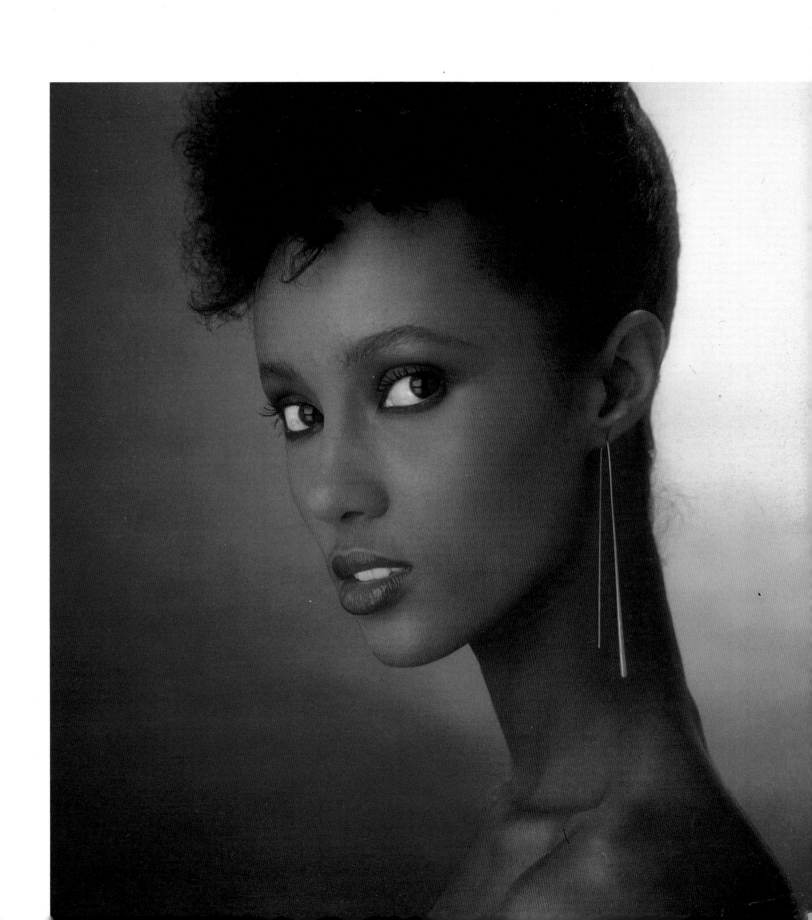

Jerry Hall, 1980

Marie Helvin and David Bailey, 1980

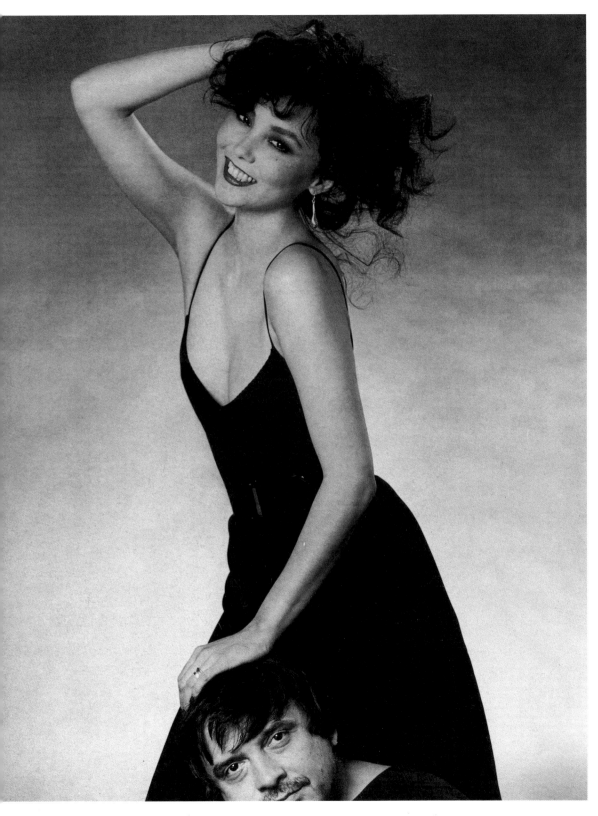

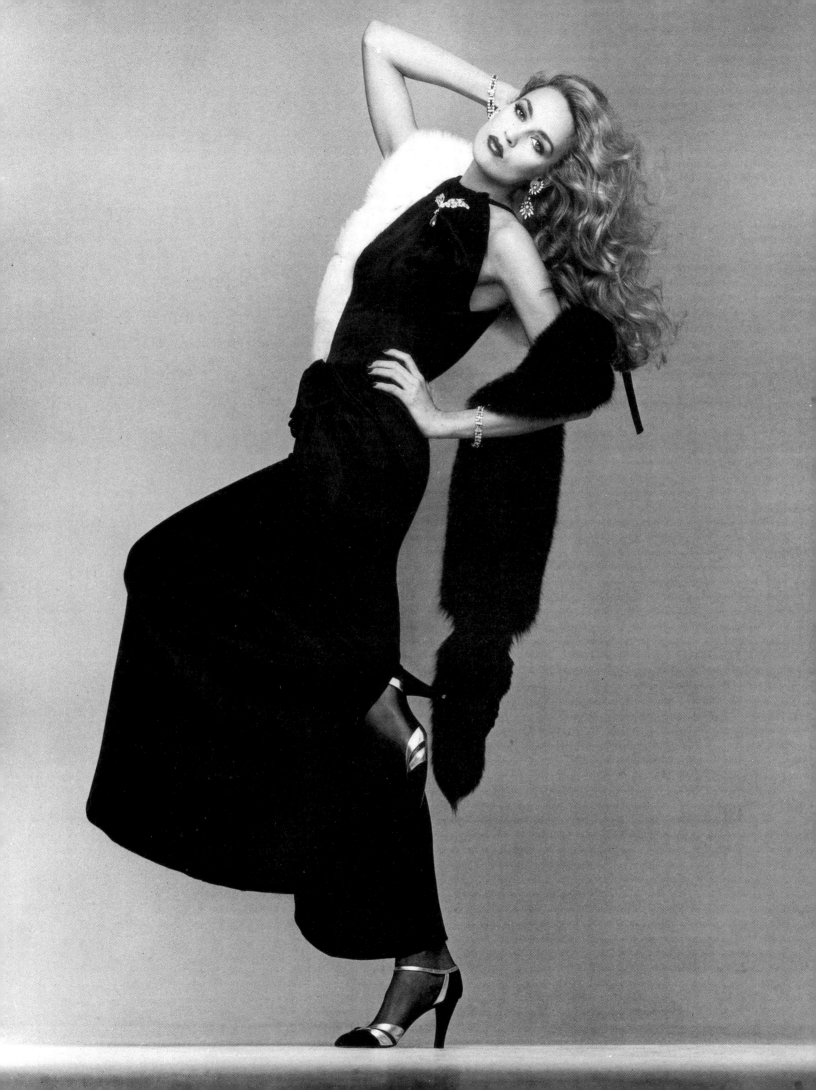

Audrey Hepburn, 1981

It will be difficult to think some day of Audrey Hepburn as the grand old lady of the cinema, and she has a long way to go before she becomes eligible for such an ambiguously complimentary title. But she stopped filming almost twenty years ago, although she came out of retirement to play a most affecting Maid Marian in *Robin and Marian* in 1976. She won an Academy Award for her playing of the princess in *Roman Holiday* (1953), but Eliza Doolittle in *My Fair Lady* (1964) and the gamine Holly Golightly in *Breakfast at Tiffany's* (1961) are probably her best-known parts.

She is half Dutch and she spent the Second World War in Arnhem, an experience which must have alternated between deadly dreariness and a brief moment of all-too-dramatic tension when the Allies tried to establish a forward position by means of a parachute drop (an episode which itself was filmed in *A Bridge Too Far* [1977]). She

met the French writer Colette in the South of France in 1951 and Colette insisted she play the leading role in a forthcoming Broadway production of *Gigi*, which was based on a novella of the same title by Colette. Since retiring she has lived in Rome, where this picture was taken.

Lady Diana Cooper, *née* Manners, the doyenne of society beauties not just during her life but arguably for all time, was photographed just after a mass picture of members of the Manners family was taken, hence the extra seats. Actually she said openly not long before her death that she was probably a Manners in name only, her biological father having probably been not the Duke of Rutland but Harry Cust. Her social position was only peripherally based on her ducal background anyway, for she was witty and well-read in a way that with society beauties is generally only found in fiction.

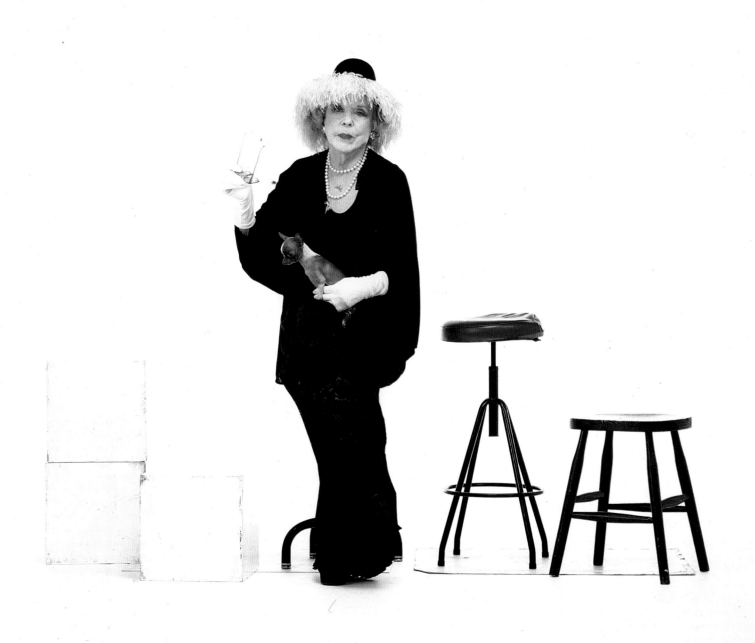

Lady Diana Cooper, 1981

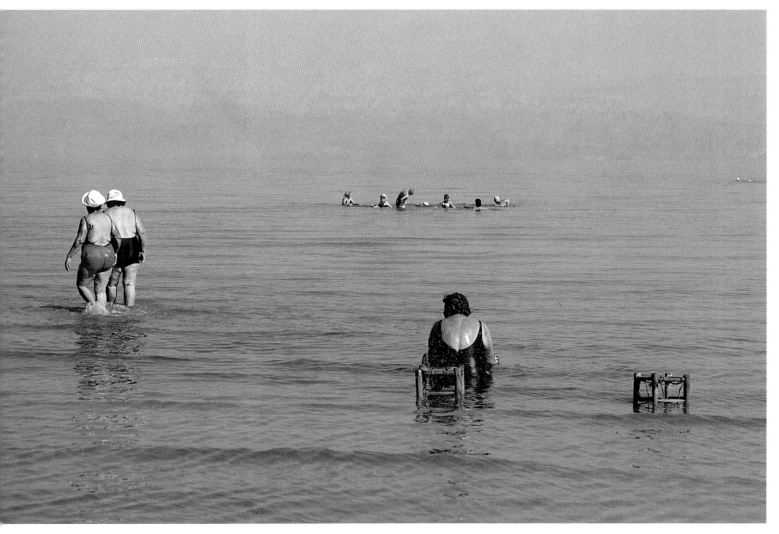

Dead Sea, 1985

The Dead Sea, over 1000 feet below ordinary sea level, is roughly five times as salty as ordinary seawater, so that bathers there float higher out of the water than anywhere else. Bathing in it is said to be like floating on an air mattress.

To travel round the world to the Seychelles to photograph a swimming pool that could have been found at home, or at any rate a good deal nearer than the Indian Ocean, may seem self-indulgent. But the light on the surface of swimming pools in Britain never has the dazzling quality seen here. And even in California the smog might have had too dimming an effect. The dazzle makes the water shimmer so that it matches the blues of the swimsuit on the model. The light in the tropics is frequently of a rather special sort in the early morning and late evening which repays the long journey from temperate zones, even though it often necessitates getting up very early once the photographer is there. Moreover suggestion rather than straight assertion is everything in these fashion shots, and the likeness between pattern of swimsuit and pattern on the water fixes the picture in the mind longer than a photograph of just a swimsuit would have done.

Seychelles, 1985

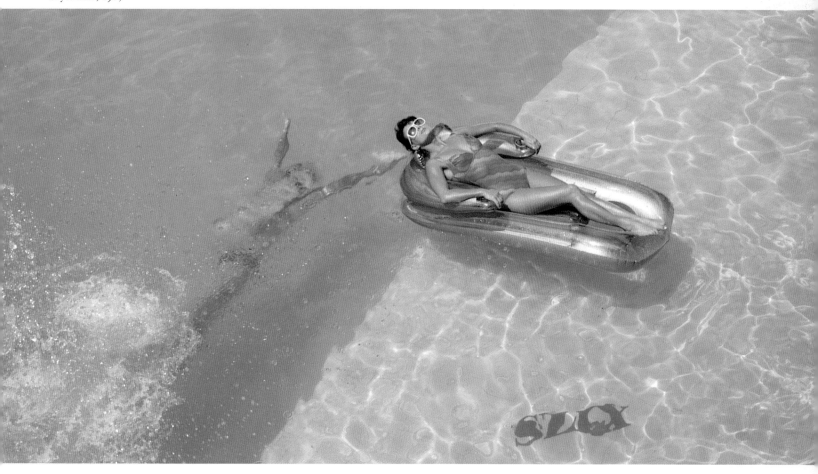

Judaean wilderness, 1986

Even the ingenuity of Israeli agriculturists must have been strained by the bleakness of the Judaean wilderness. At least the Negev Desert, which they have cultivated with considerable success, is flat. Patrick Lichfield shot the picture as part of a commission to cover landscapes in an exercise where different photographers concentrated on different photographic genres.

The Malaysian coast shot was taken as one of a series for a Cathay Pacific calendar displaying the various destinations the airline flew to. The Bali landscapes on the following pages were for a Unipart calendar.

Malaysian coast, 1985

Bali coast, 1985

Bali, 1985

Gateway to India, Bombay, 1984

Perth skyline, 1987

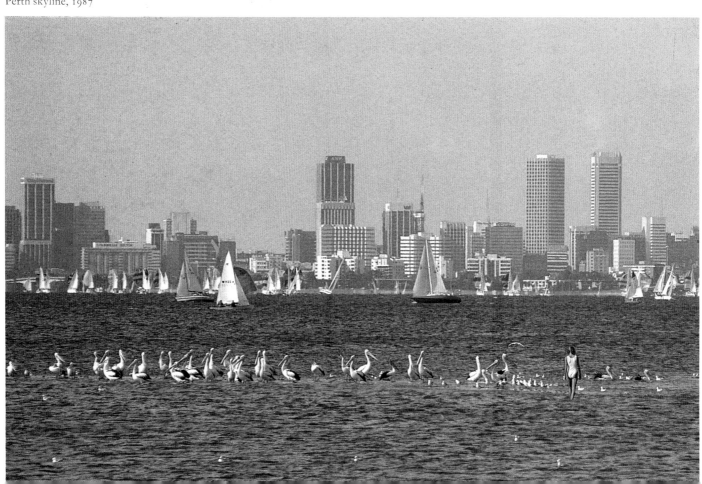

Israel, 1986

Kyle of Tongue, Sutherland, 1984

QE2, 1983

The stairwell aboard the *QE2* was shot during a cruise in which Patrick Lichfield delivered lectures on photography. Forty photographers had been asked by Olympus Opticals each to take a photograph at precisely 1400 hours GMT on 21 March 1983, the results to be published in *One Moment in Time*. The ghostly figure was Alan Whicker's production assistant, one of the few people awake at the crucial moment as the ship was cruising off Japan.

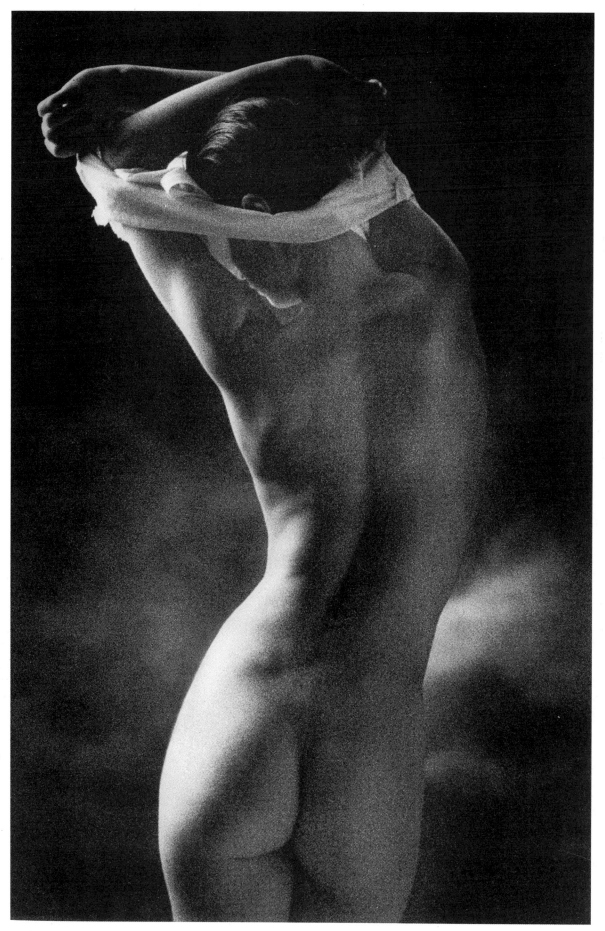

Nude, 1987

The interior shot has become a photographic genre in its own right in the past few years, not least because of the influence of the magazine *The World of Interiors*. Undoubtedly this has much to do with the public's growing interest in home decoration. The picture of a saloon at Shugborough was taken for Olympus to display the ability of the camera to cope with an awkward mixture of different kinds of light.

At Uppark the purpose was to promote British fashion, but the interior of the house is particularly interesting since many of the rooms have long been noted for their original eighteenth-century wallpaper. Indeed this must be one of very few interior shots illustrating a room that has not just been redecorated. Uppark, which now belongs to the National Trust and is near Petworth in West Sussex, has literary associations. H. G. Wells's mother was in service as a housekeeper there in the nineteenth century, and it seems likely that Max Beerbohm had it in mind when he wrote *Zuleika Dobson* (1911), for the Duke of Dorset in that book bears the family name of Tanville-Tankerton. Tanville-Tankerton is too close an approximation to Tankerville, the name of the peer who built Uppark in the seventeenth century, to be entirely coincidental, especially considering the story the Duke of Dorset in *Zuleika Dobson* tells of his ancestor who, as a very old man, married a dairymaid. An Uppark baronet of the early nineteenth century married his dairy maid when over 70.

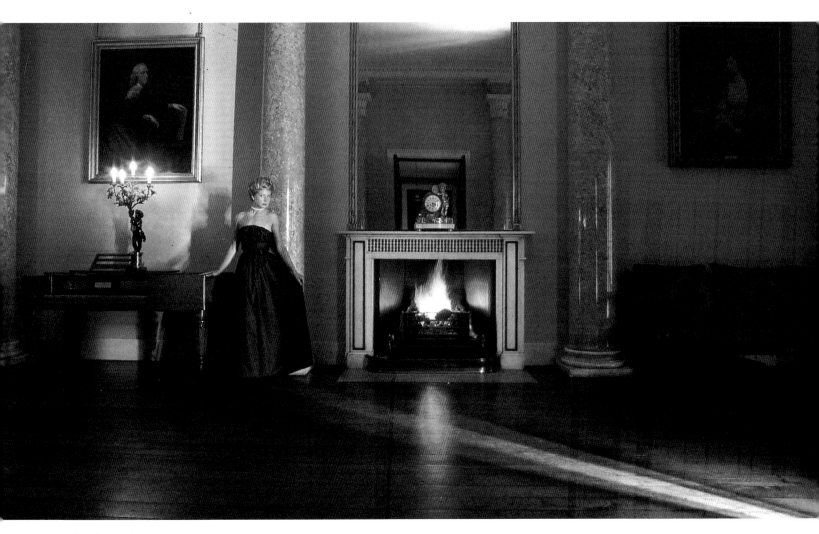

Shugborough, 1985

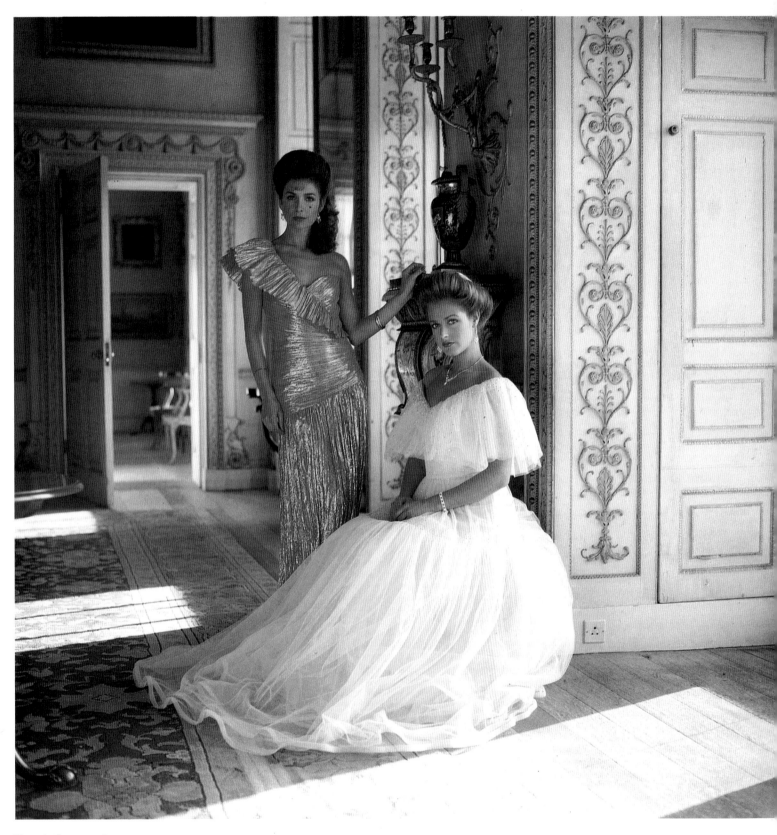

Uppark, Sussex, 1982

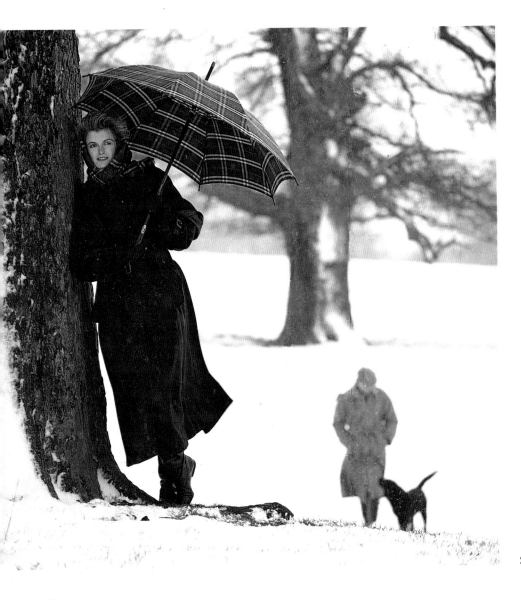

Shugborough, 1987

Uttoxeter, Staffordshire, 1980

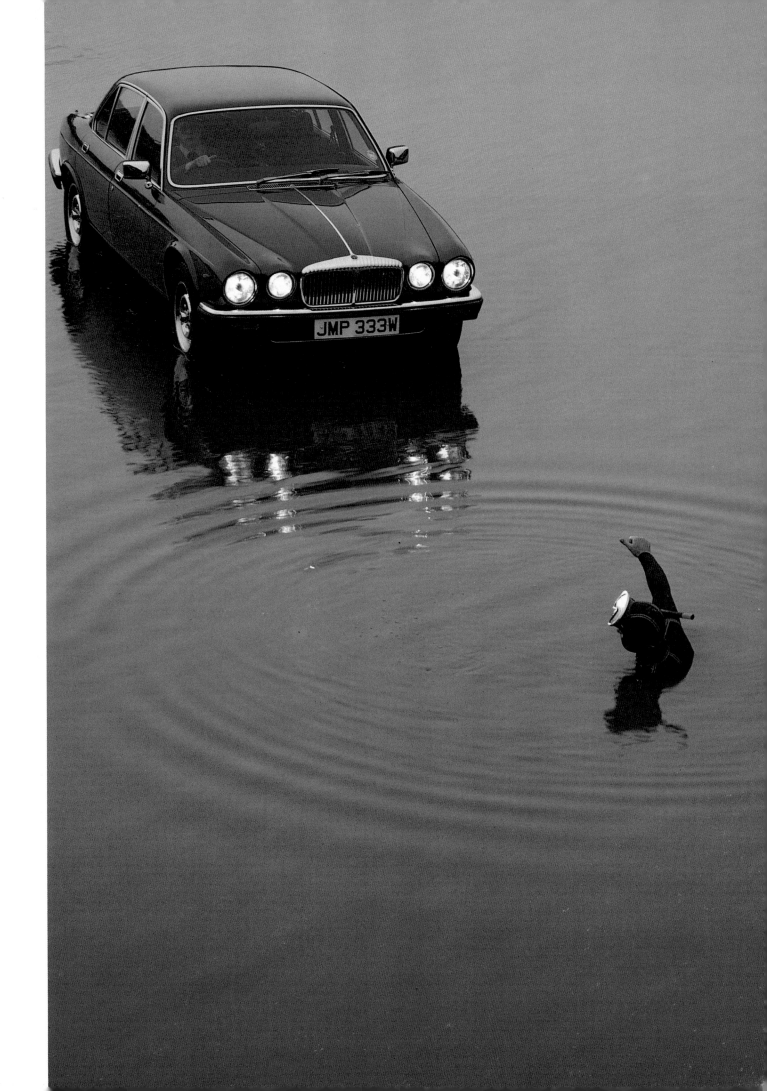

Blacksmith, Berkswell, Warwickshire, 1986

The blacksmith is a real working blacksmith; his forge is in the Warwickshire village of Berkswell. It is slightly disconcerting to find a blacksmith apparently using oxyacetylene cylinders, but if rural England is to be preserved at all (the picture was commissioned by the Council for the Preservation of Rural England) the traditional bellows may not be up to modern requirements. The countryside around Berkswell – an oasis between Coventry and Birmingham – is currently under threat from the National Coal Board, which wants to mine in the area.

The schoolroom at Harrow is a workplace too, on equally traditional lines. The figures were the oldest Old Harrovian extant with the youngest boy in the school at the time.

Harrovians, Fourth Form Room, Harrow School, 1981

THE PHOTOGRAPHER'S CHILDREN:
(above) Lady Eloise, 1983;
(right) Lady Rose, 1987;
(far right) Viscount Anson, 1987

Index

Picture Acknowledgements

The Earl of Lichfield and the publishers would like to acknowledge and thank the following for allowing them to publish the photographs on the pages indicated:

Allan Brady and Marsh: 121; Allied Irish Banks plc: 170; Associated Newspapers: 67; Bayer Pharmaceuticals: 1, 132–3; Benton and Bowles/Daimler: 201; British American Tobacco: 128(a and b), 129, 130–1; British Heart Foundation: 122, 124–5; Brooke Shields and Co.: 180; Camera Press: (Elizabeth Ramsay) 10, (Richard Imrie) 13(l), (Dmitri Kasterine) 13(r), (Tom Blau) 17, 33, 35, 54(a), 89, 90, 91(a, bl and br), 138, 145, 146, 147, 149(a); Cathay Pacific Airways: 189, 192(a); Central Office of Information: 199; Collett Dickenson and Pearce/Olympus cameras: 198; © The Condé Nast Publications Ltd.: 16, 27, 34, 39, 40, 50, 53, 54(b), 56, 59, 61, 63, 64, 71, 72, 80, 92, 93, 97, 100, 101, 104, 106, 111(l), 116, 135; Connell May Steavenson/Burberrys: 200; *Cosmopolitan*: 107, 112(r), 113; Council for the Protection of Rural England: 202; *Country Life*: 29; *Daily Express*: 28; *Daily Mail*: 120; *Daily Telegraph*: 111(r); Decca Records: 170(l); Dunlop: 151; Foote Cone and Belding/Pears: 134; Garratt Baulcombe Associates/Morley:

98; Harry Winston: 177, 178(a and b); Harlech Television: 179; *Harpers Bazaar*: 150, 152–3, 174; *Harpers and Queen*: 115; Hombard Ltd: 172; J. Walter Thompson/Rolex: 119; Peter Kain: 14; Kodak: 203; Kodak/Levine: 186, 188, 193; *Kohinoor*: 166; *Lady's Home Journal*: 173; *Life*: 25; Living Without Cruelty: 170(r); London Weekend Television: 168(l); Macmillan Publishers: 2; Market Design and Advertising/Slix: 187; *National Enquirer*: 114; *Newsweek*: 118; Ogilvy Benson and Mather/ICI Savlon: 136(r); *People*: 117; Pitkin Press: 148; *Queen*: 32(r), 57, 69, 74, 76, 77, 95; *Radio Times*: 105; *Ritz*: 112(l), 123; Sotheby's, London: 12; Springer Press: 108; *Status*: 30, 51, 60(l), 68, 79; *The Sunday Times*: 31, 58; *Tatler*: 102, 185; *TV Times*: 167(a), 169(l); Unipart: (Chalky Whyte) 81, 99, 154(a and b), 155(a and b), 160, 161, 162, 163, 190, 191; *Vanity Fair*: 149(b); Vernon Stratton/Berkertex: 94; Warner Brothers: 109; White Horse whisky: 156, 157, 158, 159, 192(b); Chalky Whyte: 15; *Woman*: 167(b).

Key

a: above, b: below, l: left, r: right